FIGURE PAINTING IN WATERCOLOR

FIGURE
BY CHARLES REID
PAINTING IN
WATERCOLOR

WATSON-GUPTILL PUBLICATIONS/NEW YORK
PITMAN PUBLISHING/LONDON

751·422

78923

Published in the U.S.A. and Canada by Watson-Guptill Publications,
a division of Billboard Publications, Inc.,
165 West 46 Street, New York, N.Y. 10036

Published in Great Britain by Sir Isaac Pitman & Sons Ltd.,
Pitman House, 39 Parker Street, Kingsway, London WC2B 5PB

Manufactured in Japan

(U.S.) ISBN 0-8230-1710-9
(U.K.) ISBN 0-273-31799-7

Library of Congress Catalog Card Number: 74-175245

First Printing, 1972

This book is for Sarah and Peter.

ACKNOWLEDGMENTS

I would especially like to thank Don Holden, Watson-Guptill Editorial Director, for his very necessary suggestions and encouragement. I'm sure I couldn't have managed without him. Much credit must go to Adelia Rabine and Heather Meredith-Owens, my editors, who had to sort through and give order to my often shaky prose. I'd also like to thank Jack Pellew who suggested that I do the book in the first place. Finally, I'd like to thank my wife and my mother, each, in her own way, made this book possible.

CONTENTS

FIGURE PAINTING IN WATERCOLOR

INTRODUCTION

A prospective student once asked Winslow Homer if he would consider taking her on as a pupil and teaching her how to paint in watercolor. After recovering from the shock, he asked the girl if she had mastered oil painting. She had to say that she hadn't, and Homer was off the hook. He quickly told the girl to become accomplished in oils before attempting watercolor.

Homer was a rather crusty fellow, and he probably wasn't interested in taking on a student. However, besides avoiding a pupil, Homer made a good point. A sound foundation in oil painting can be helpful in establishing good value relationships. But aside from this, watercolor isn't any more difficult than other media. Of course, each medium has its own peculiar problems that must be mastered and in this book I've tried to point out the problems that are unique to watercolor.

I feel that the main problem in watercolor is attaining a good paint consistency; after this is mastered, a good part of the mystery of successful watercolor painting should be solved.

Naturally, there are still the basic principles inherent in all media: drawing and values. Even nonobjective art needs good drawing and good values. Color also must be considered, whether you're involved with oil or with watercolor. In addition to discussing watercolor technique, I've tried to go into these basic painting principles in some detail. However, drawing is really a book in itself and beyond my scope here. You should definitely obtain one of the good drawing books on the market. This is a *must* if your figure drawing is weak.

Finally, I'd like to dispel the ideal that watercolor painting becomes easy for someone who does it for years. In my case, at least, watercolor continues to be an often maddening challenge. Few of my pictures come out the way I want them to, and I throw away many more than I keep. So try not to become too discouraged; we're all in the same boat.

In order to make the painting techniques as clear as possible, I've done a different piece of art for each step in the projects instead of showing one painting from start to finish. While this procedure has made it impossible for the steps to duplicate the finished art stroke for stroke, it has allowed me to plan the sequence of instruction more carefully. So don't worry about the inconsistencies you'll sometimes see in the illustrations; I know they're there!

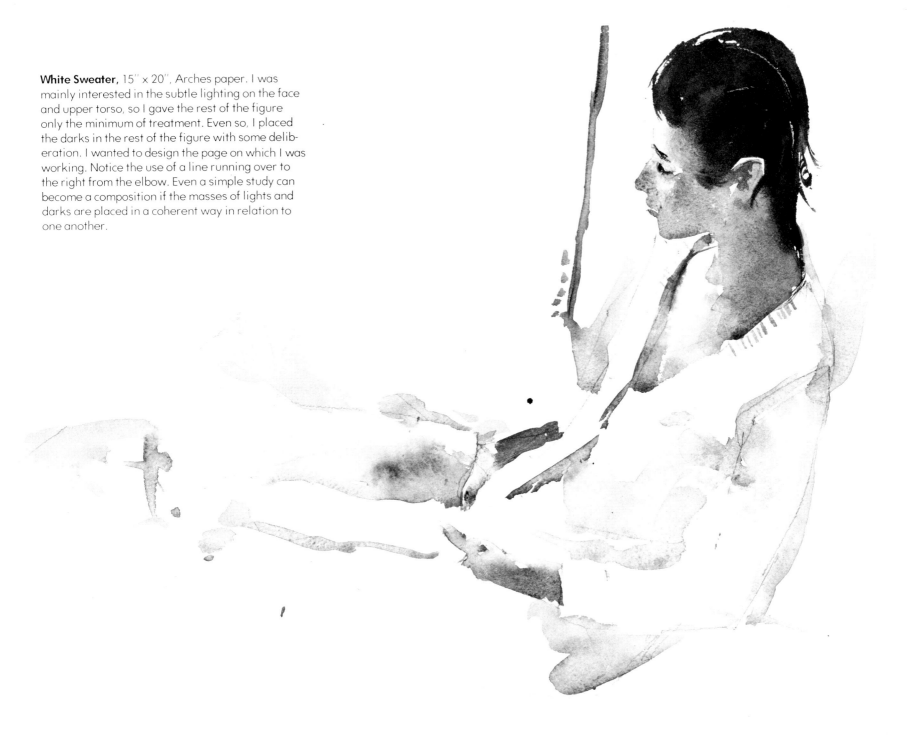

White Sweater, 15" x 20", Arches paper. I was mainly interested in the subtle lighting on the face and upper torso, so I gave the rest of the figure only the minimum of treatment. Even so, I placed the darks in the rest of the figure with some deliberation. I wanted to design the page on which I was working. Notice the use of a line running over to the right from the elbow. Even a simple study can become a composition if the masses of lights and darks are placed in a coherent way in relation to one another.

MATERIALS AND TOOLS

I have a fisherman's tackle box brimming with brushes of all sizes, piles of tube colors—some of which are empty—razor blades, kneaded erasers, pencils, facial tissues, and my palette. Not being a particularly organized person, I find that my box has a lot of stuff I never use. Many of the brushes are very tired, with the paint chipped off the handles and sagging bristles. Many are sizes that I never use.

If I were organized, I'd probably have three brushes, about six tubes of color, one razor blade, one kneaded eraser, a box of tissue, a 2B pencil, and my palette. My bad habits are established, but I'd like to see you develop better ones. I'm sure it would make the job of painting a picture much easier if I didn't have to sift through a pile of used-up tubes to find one with some paint in it!

Brushes

The three brushes I'd suggest would be 1" flat, a number 8 round, and a small, round number 3 or number 4.

You may buy either sable or oxhair brushes for watercolor. The sable brushes are more expensive, and worth the investment, I think. I like their "springy" quality and find that they point better than the oxhair. For figure painting, a brush that points well is a great joy. Speaking of expense, I think that the business of painting a watercolor is hard enough without hampering yourself with poor tools. If you can possibly afford it, buy good sable brushes.

For the actual painting of the figure, don't continue to use a brush that won't take a point. As I've said, I can't bear to throw away brushes. When they get weary, I save them for drybrush areas and backgrounds where a good point doesn't matter. It's a shame to use a lovely new brush to scrub in a background.

Paper

I use all sorts of papers, but I do feel that a paper must be fairly absorbent to work well. Don't try to paint on hard, shiny, nonabsorbent papers unless you like the special effects that these papers produce. A hard paper repels the paint. Some great things *can* happen, but there's always the danger of merely being tricky, a quality I don't find very attractive in painting. One watercolorist, whom I greatly admire, works on shelf paper and does great things, but his work is definitely offbeat and by no means in the realm of traditional watercolor painting. As in everything, you must find the paper that suits you best. My watercolors are pretty conventional, and because of this, I use the conventional papers.

For full sheet paintings (22" x 30"), you

should probably use at least 140 lb. paper, and preferably 300 lb. The thick 300 lb. paper will take a lot of punishment and still won't buckle. The thinner 140 lb. can't be worked into as much, but it's cheaper and might be fine for your particular way of working. Some of the sketches for this book are done on 72 lb. paper which is really too light for anything, but I got a bargain on it. The paintings were only quarter sheets, but even then the paper buckled quite a bit.

Watercolor paper comes in three categories: hot-pressed, cold-pressed, and rough. For figure work, I prefer either hot-pressed, which means smooth, or cold-pressed, which means medium rough. I find the rough paper hard to handle for figure work because of its heavy texture.

Each brand of paper differs. A cold-pressed paper of one manufacturer might be harder or softer than that of another. Try several different makes until you find the one that suits you. I feel that you should be prepared to buy a good paper, but unfortunately, a good paper is expensive. I'd rather see you buy lighter weight paper of good make rather than the so-called student-grade papers available. These student-grade papers seem pretty grim to me. *Don't* buy "all-purpose" papers that purport to be good for all mediums. They're horrible and literally impossible to do a decent painting on. I'd rather see

you paint on the shelf paper I mentioned earlier. At least you'll have a bad time cheaply!

Watercolor Boxes and Palettes

As I mentioned earlier, I carry all my painting things in a tackle box. It's made out of sturdy, heavy-grade plastic and is quite light. These boxes are made in several sizes. Mine is about 14″ x 6″ x 8″. I bought it at a local discount store. I carry too much in it, and I think I could probably get along with a much smaller one. However, this one has the merit of carrying everything, including water jars and a box of tissues, as well as my palette. There are also compartments for brushes, razor blades, paint tubes, etc.

My palette is a folding metal one that came with a tube box, but the tube box didn't seem to be made for transparent watercolor tubes, so I discarded it. Don't buy the palettes that include cake paints, nor the cheap, plastic palettes. The plastic boxes aren't very sturdy, and washes don't seem to mix well in them. I use my palette in my studio as well as for sketching outside. Another good palette for studio use is an enamel butcher's tray, which has the advantage of a large mixing area. If you're going to do most of your work in the studio, the butcher's tray would be the best palette for you.

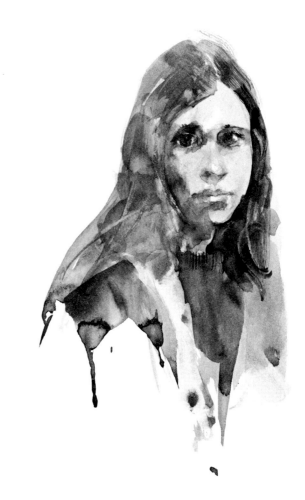

Brown Sweater, 8″ x 10″, Bristol paper. I wanted a simple, uncluttered look so I combined as many of the darks as possible. Notice how the hair blends with the shadows along the side of her face. I wanted to stress the eyes so I used the most definition here.

Easels

I don't use an easel for my watercolor work. I once invested in a watercolor easel, but I found that it was such a pain to cart it around that I soon left it home. If I'm working outside, I simply sit or kneel. If it's desirable to tilt my board, I find some handy rocks. Otherwise, I just set the board on the ground.

There are times that I've wished for an easel, but carrying one is just too much trouble for me. When I see students struggling with "portable" easels, I think of how perverse the man must have been who invented them. If you're mechanical and love to solve thorny problems, the problem of the portable easel is for you.

Still, the greater part of your figure work will be done in your studio or in a sketch class. Two chairs, one facing the other, will make a fine easel. Sit in one and prop your board and paper against the back of the facing chair. There should be room for your water container and palette on the seat.

Colors

I'll go into a complete discussion of the different colors I use later in Project 14. In general, buy professional-grade paints, although the student-grade watercolor paints seem to be of a higher quality than student-grade brushes and paper. Be sure to buy *transparent* watercolor, not gouache, which is an opaque watercolor. Always buy tube paints, since it's a good idea to put out fresh color each time you start a new painting.

Miscellaneous

I use a regular studio drawing board when I'm working in my studio, and there are several types of good ones. There are two basic requirements for a drawing board: it must be very stable; and it must be able to swing from a vertical position to a horizontal one. When working outside, I carry a fairly small board, about 16" x 23", large enough to handle a half-sheet (15" x 22") watercolor paper. A piece of plywood is nice and light, as well as being cheap, and it makes an adequate surface to work on.

I complete my kit with single-edged razor blades, pencils, a water container, and a kneaded eraser. Too much scratching out with a razor blade can really mess up a painting, but a few prudent scratches can be very effective. I like regular number 2 office pencils. Harder pencils tend to dig up the paper. I suppose HB drawing pencils would also be fine; I've just got into the habit of using number 2's. A kneaded eraser is the best overall eraser for me. It does a good job without disturbing the paper, but *any* eraser will disturb the softer papers, so don't get into the habit of relying too much on your eraser. I use two plastic jars for water—the kind of container used to pack dessert toppings and margarine. They fit into my box; the tops fit snugly and don't leak. Army canteens are favorite water containers for painters, but I can't fit one into my kit. A Spanish wineskin called a "boda" works beautifully, but somehow I prefer carrying it full of its intended contents.

I'm forever indebted to the man who invented facial tissue. I find it a necessity for blotting areas that are too wet, mopping up excess paint, scrubbing out offensive areas, lifting out lights, and blotting my brush. My more frugal friends use paper towels, but they don't have the same magic for me.

Sleeping Model, 12" x 19", Arches paper. I wanted this figure to become a large, simple shape, so I used a minimum of separate shadow shapes. The head and the large mass behind the head blend into a single dark value. The composition isn't a conventional one; instead it's the shapes of lights and darks that interest me. You should be aware of what makes a good, well-knit picture, but you should also be willing to break those rules if there's a certain off-beat quality that appeals to you. The stripes contrast with the simplicity of the body and with the background. The sheet, the body, and the area behind the figure all form a light mass. Avoid having bits and pieces of light and dark spread throughout a composition, unless they develop a cohesive thread running through the picture.

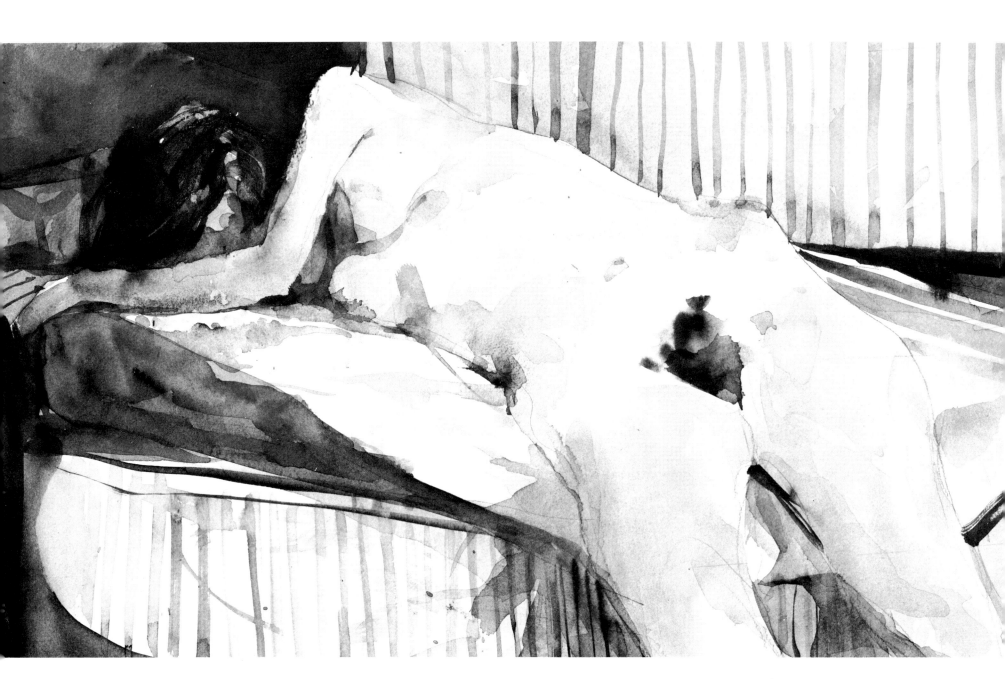

PAINT CONSISTENCY

Good paint consistency means the workable mixture of pigment and water that's suitable for a particular technique you plan to use. In most cases, the pigment that comes from the tube is too thick and dry to use alone. (The most important exception is drybrush, which I discuss in Project 6; in almost all other cases, the pigment needs help.) Sometimes you add water to the paint on the palette. In other cases, you add pigment to water which you've applied to the paper first. (This last process is called wet-in-wet, and I'll devote a whole section to it in Project 5.) Regardless of *when* the water is added, you must never use too much in your mixture. Probably the most common cause of failure in watercolor paint is using too much water and too little paint.

In this project, I'll discuss mixing the simple washes you'll use throughout your figure work. You'll need a number 8 round sable brush, a quarter sheet (11" x 15") of watercolor paper, a tube of ivory black or Payne's gray, tissues, a jar of water, pushpins, and a drawing board.

Attach your paper to the drawing board with a pushpin at each corner. Fix the board so it's comfortable for you. Sometimes I'll suggest a certain angle or position for the board, but in this case, it can either be tipped a bit or held horizontally.

Squeeze a generous amount of paint onto your palette—about a fourth of a tube. This seems wasteful, but you must learn to be lavish with your paint if you're going to succeed. For the time being, *use only fresh paint that you've just squeezed out.*

Dip your brush into the water supply. Then, before putting the brush into the paint on your palette, give the brush two very hard shakes to get rid of some water. Now dab it into the paint. Don't just nibble at the edge of the paint, really fill your brush with pigment.

Paint Consistency: Step 1 Apply your loaded brush to the paper, making a simple square, about 2" x 2". Don't carefully plan the strokes but fill the square boldly. If you overlap the boundaries of the square, don't worry. It's not important.

Paint Consistency: Step 2 If your wash is too dry, like this one, and the brush drags across the paper, make another square, shaking a little less water out of your brush. Remember you want a *fluid* stroke. You don't want one that's too watery or one that's too dry.

Paint Consistency: Step 3 If the wash is too watery, like the one shown here, you know that more water must be shaken from the brush before you put it into the paint supply. Now I'd like you to repeat the same process, but instead of shaking the water from the brush, try blotting the brush with a tissue before attacking the paint supply. Both ways of limiting the amount of water in the brush are fine. The only problem with tissues is that you might overdo the blotting and make your brush too dry. Shaking is often the easiest method of arriving at the proper amount of brush dampness, but it's a bit hard on the surrounding rugs and furniture. Because of this I'd suggest that you master the tissue method too.

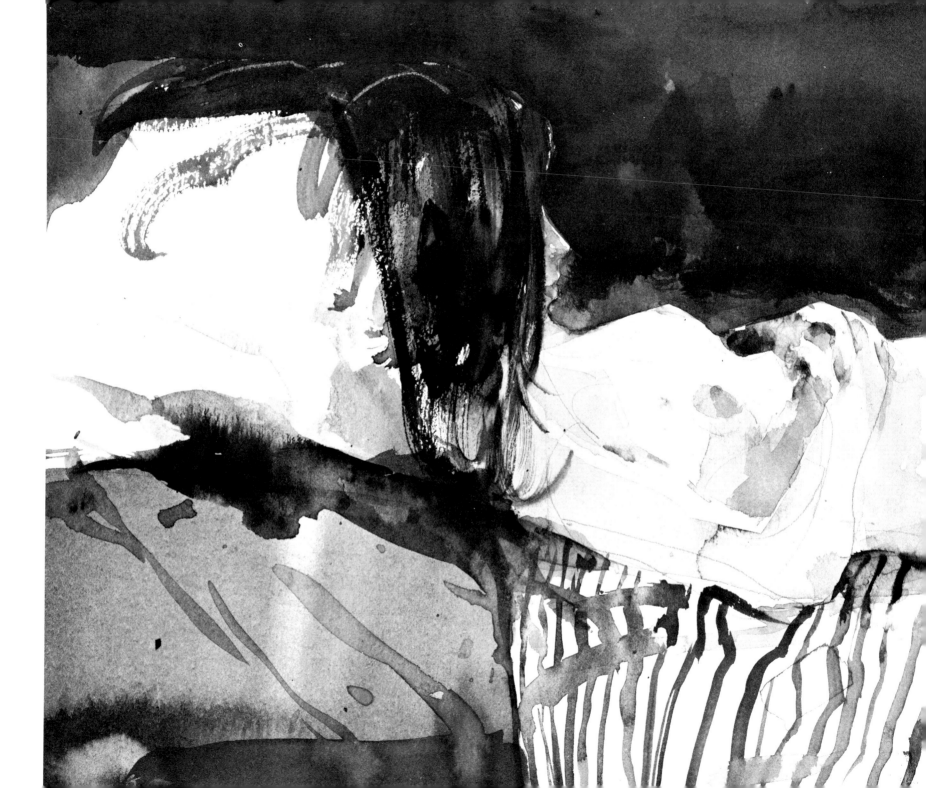

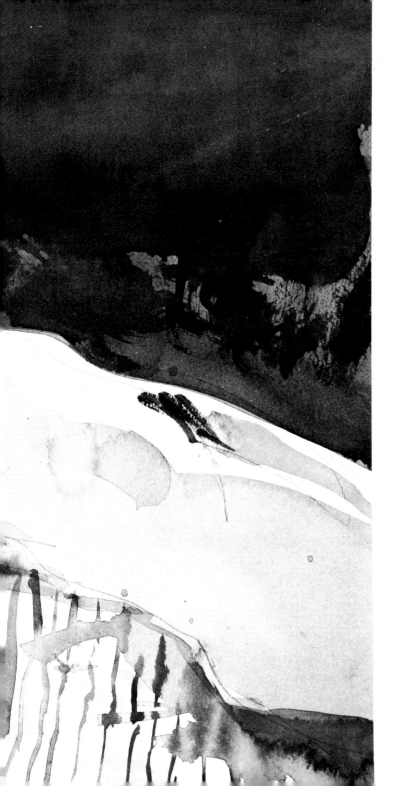

Reclining Nude, 9½″ x 15″, Fabriano paper. I was taken with the way this scene was divided. A line of the hair continues on down into the division of the two sections of the couch. I wanted to contrast the stripes in the couch with the simple sections of the area under the pillow. The pillow itself also had a pattern, but I decided to leave it as a simple, high-keyed area. I felt that it would help the balance of the painting. The model had a cool complexion, so there's little warmth in the flesh tones. I didn't paint the dark background right down to the light-struck flesh tones. This would flatten the picture out. To darken a background, just darken some small sections of it. Don't fill it in as if you were painting a wall. I completed the figure itself on the spot, but I made the decisions on the surroundings when I got back to the studio. When you're in your studio, you can make compositional decisions with more care and deliberation. I often act too rashly when I'm working on the spot, and after all, the main thing to get when working from the model is the model's complexion, gesture, and shapes. The rest of the picture can be changed to your heart's content to develop the strongest possible pattern.

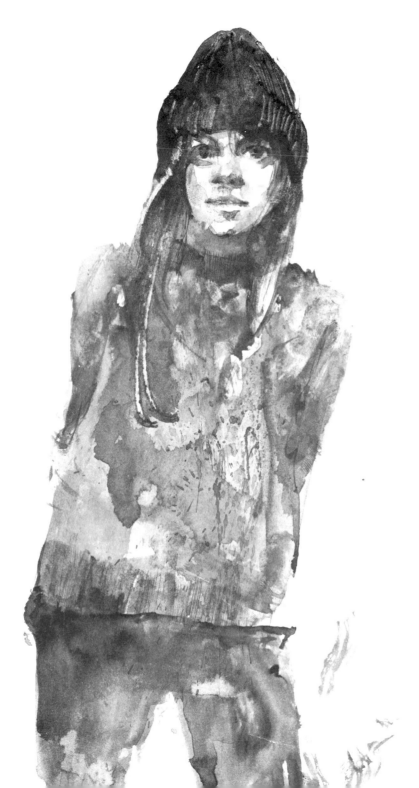

Wool Cap (Left), 8" x 10", Bristol paper. I like "straight" natural poses especially in children. The combination of gracefulness and awkwardness is intriguing.

Trout Fishing (Right) 11" x 10½", Fabriano paper. I like to do watercolors from photographs just for the sake of practice. I did this sketch from a small photograph which appealed to me because of the close values between the figure and the background. The only thing really separating the background from the figure is some light-struck areas; otherwise, the values between the figure and the background are almost the same. I wanted to get a "lost and found quality" here, using the close values in some areas and the definite value contrast in other sections. Notice the soft edges in the shadow areas as opposed to hard edges out in the light.

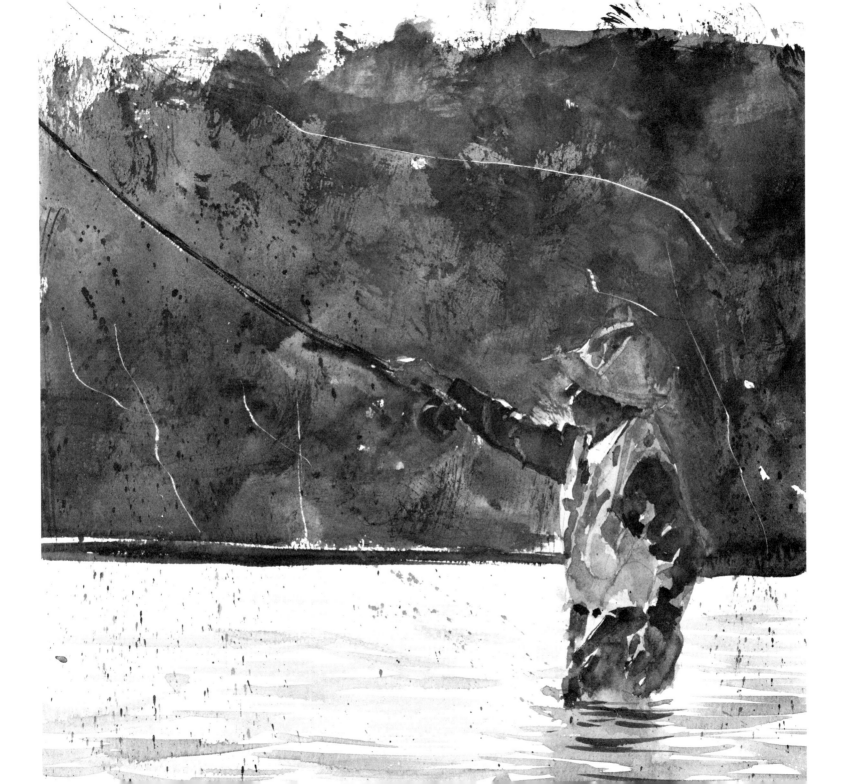

2

FLAT WASH

This exercise will show you one of the most important techniques for painting the figure in watercolor, making a flat wash—a simple, flat tone. To master the flat wash, you'll use what you just learned about paint consistency.

The wash needn't be perfect, like a painted wall; irregularities add "personality." But if your wash isn't reasonably flat—the same tone throughout—your paint consistency is probably wrong. Perhaps you're using too much water, or maybe too little. Don't go back and try to correct it; you'll only make it worse. Start a new wash if the wash is too watery, using a bit more pigment in the mixture. If the pigment is too heavy and unworkable, on the other hand, try adding a bit more water to your puddle. Try again until you get the paint consistency right.

You'll need a small sheet of good quality watercolor paper, about half the size of this page, a number 8 round sable brush, some pushpins, a ruler, an HB pencil, a tube of ivory black or Payne's gray, tissues, a jar of water, and your drawing board.

Attach the paper to your drawing board with the pushpins, one in each corner of the sheet. Set your board in a horizontal position. A level surface isn't always necessary—many watercolorists tilt the board up at the back—but I'd suggest a horizontal board for this exercise. The wash won't want to run, as it will if the board is tipped. Now, with your ruler, rule a rectangle that will cover almost all of the sheet.

Flat Wash: Step 1 Mix a very generous puddle of water and tube color on your palette. Make sure that the puddle has more than enough water-pigment mixture to cover the whole rectangle. If you run out of fluid color halfway through the wash, you'll be in trouble. You won't be able to mix a new puddle with exactly the same combination of pigment and water, and you'll have a two-tone rectangle instead of a flat wash. Load your brush from the puddle and run the brush along the top line of the rectangle. Keep the brush moving with a broad, steady stroke. Don't stop until you reach the right-hand margin. (I'm assuming that you're painting from left to right.) At the end of the stroke, make a short jog downward with the tip of the brush.

Flat Wash: Step 2 Quickly recharge your brush and run it back along the bottom edge of the strip you've just painted—the strip's still wet, of course—so that the new stroke overlaps and runs into the old one. Work steadily. You don't want the wash to dry before you finish the rectangle. When you reach the next margin, make another jog downward.

Flat Wash: Step 3 Repeat the process—back and forth—until the rectangle is filled. You've completed a flat wash, probably with a few flecks of white and subtle irregularities that add to its vitality.

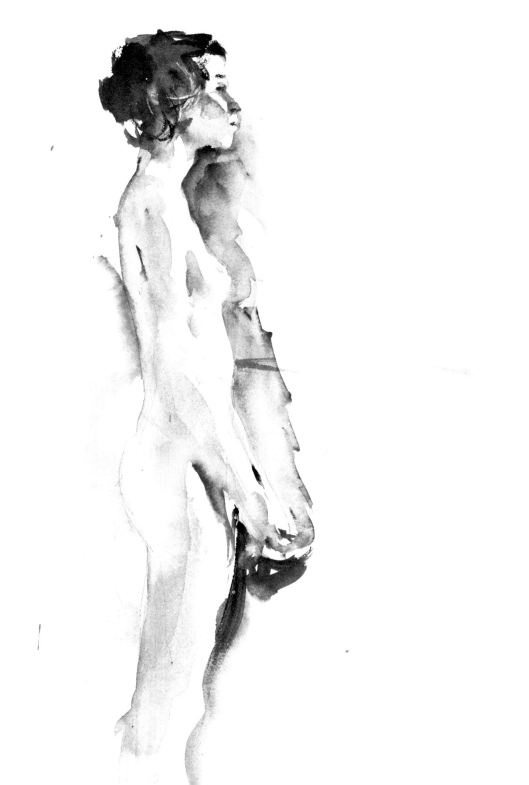

Standing Nude (Left), 20" x 15", Fabriano paper. First I washed in the whole figure with a light wash which was allowed to dry. Next I put in the big shadow shapes. The light was clear, so the shadow shapes were definite. This is a simple, two-value figure. Since the shadow side of the arm is lost, there are no specific shapes here. I picked out a little definition around the elbow and breast, but you still get the feeling of the arm's presence without any real explanation here. Notice the use of hard and soft edges on the front of the upper torso. The harder edges face the light but become softer as the forms turn away from the light. Sometimes I add pure colors directly to the painting, and other times I work directly on the paper, mixing the washes as I develop the light or shadow area. The latter is a dangerous procedure. The colors tend to be much stronger, and they do not mix completely, but I rather like this quality.

Alice (Right), 11" x 10", Fabriano paper. This was done from a slide. I was interested in it because of the effect of the brilliant light on the figure standing against a wall which held many posters. I indicated the texture of the wall with spatterwork. A few letters and definite boundaries of the posters are shown, but in general, the whole wall is only suggested. It's good to give the *impression* of an area such as this wall, but there's no reason to get too involved. I was more interested in the figure and the effect of brilliant sunlight on her. I first put in the flesh tone, leaving all the clothing areas untouched. Next I worked with the big, simple shadow shapes on the clothing areas. Notice how the shadows in the skin have flooded out into the shadows on the sweater and shirt. I gave the folds in the clothing a perfunctory treatment with just a few indications. Nevertheless, I'm careful to place the few folds that I do show in such a way as to explain the character of the cloth, at least in a general way. I added a little pattern to the shirt to break up the monotony of the white shape.

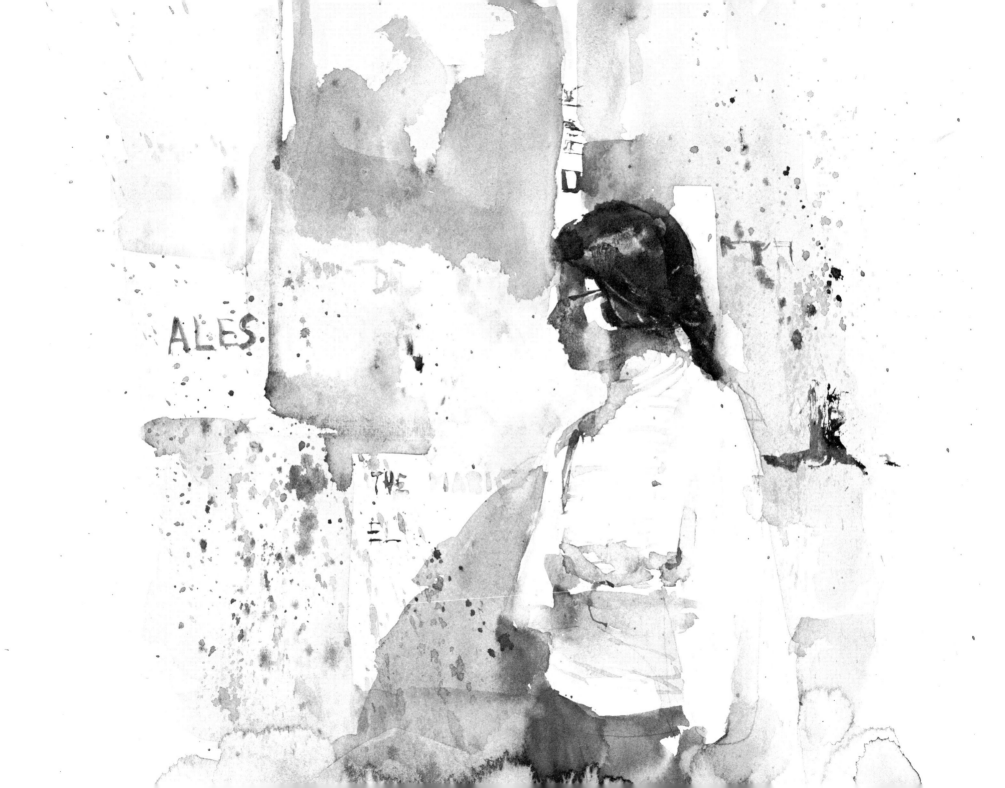

3

THREE VALUES IN FLAT WASHES

Now you'll use a flat wash in three different values, put together in the form of a cube. This project is intended to show bulk and three-dimensional form, using the simplest possible means. Later, you'll learn to show bulk and form in a figure, but you'll have the additional problem of blending light and shadow. Blending is difficult, so first get an idea of form by making a simple cube form, where you can leave hard edges between the light, middle, and dark areas.

Don't worry if your first cube doesn't have a perfectly even transition from light to dark. This project will give you excellent practice in controlling values, by regulating the proper amount of water with the proper amount of pigment needed to make a specific value.

You'll need the same materials used in Project 2.

Since "runny" washes should no longer be a problem, hold your board in the way that's most comfortable for you. Many watercolorists prefer to stand as they paint, so they can wander around and see their work from several angles. This mobility helps them keep a fresh eye. Others prefer to sit and tilt their boards to a comfortable angle. Sometimes I work with the board in an almost vertical position. Try the various possibilities to see which suits you.

Three Values: Step 1 After attaching your paper to the board with pushpins, sketch in a cube by making two overlapping squares and connecting three of the corners with straight lines.

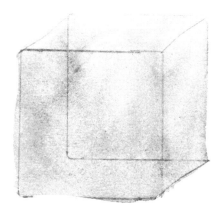
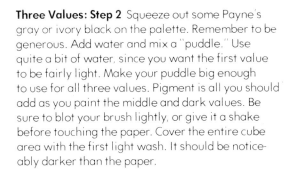
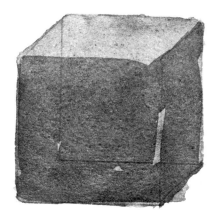
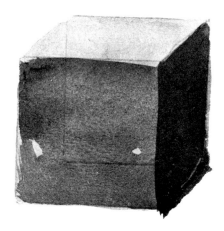

Three Values: Step 2 Squeeze out some Payne's gray or ivory black on the palette. Remember to be generous. Add water and mix a "puddle." Use quite a bit of water, since you want the first value to be fairly light. Make your puddle big enough to use for all three values. Pigment is all you should add as you paint the middle and dark values. Be sure to blot your brush lightly, or give it a shake before touching the paper. Cover the entire cube area with the first light wash. It should be noticeably darker than the paper.

Three Values: Step 3 Now comes the middle value. Add more pigment to the same puddle you used in Step 2. Hopefully, the puddle was big enough so that you don't have to add any more water. Don't forget to give your brush that shake or blot after loading it from the puddle. After your first wash is dry, paint the second value over the bottom two sections, leaving the top section untouched in this step. Let this wash dry.

Three Values: Step 4 Use the procedure discussed in Step 3 to mix a shadow value. This time use even less water and more pigment. Fill in the lower right square with the shadow value, and the cube is complete.

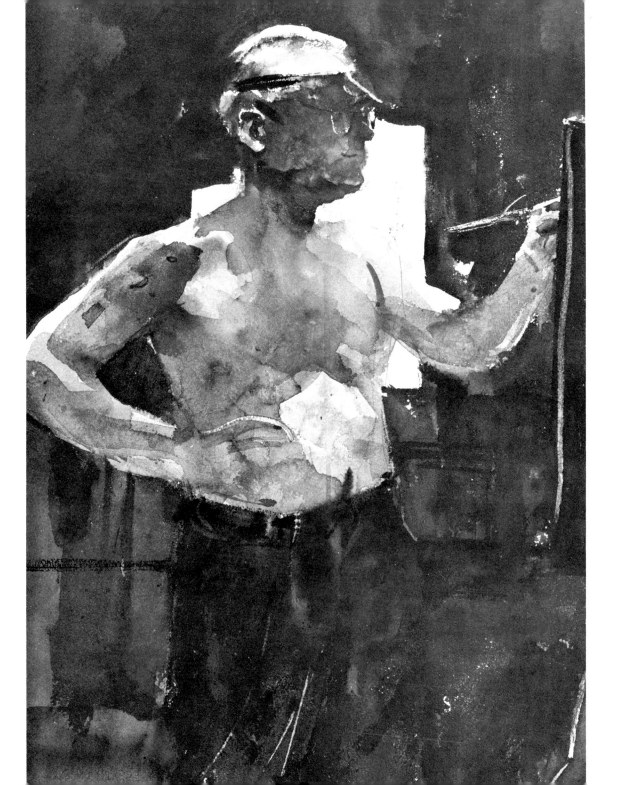

Joe (Left), 16" x 12", Fabriano paper. I did this painting during a sketch class. It was a hot night, and I was struck by my friend's physique, so instead of painting the model I painted Joe. The thing that interested me most was the way the light was hitting the top of his head. I contrasted the dark shadows underneath the visor with the high-keyed areas in the forehead, hair, and ears. I really let myself go with the color, using a great deal of cerulean blue. In fact, this color took over, and the effect isn't quite what I would have wanted had there been more time to think about what I was doing. When you work quickly from life, you must settle for your first decision. There isn t time to make a lot of changes. However, first decisions often have a certain charm and validity all their own.

Seated Model in Draped Chair (Right), 15" x 20", Fabriano paper. I cut off the top of the model's head to tie in the figure with the picture borders. The upper torso and head were done with a single wash, wet-in-wet. When the areas dried, I added small, dark indications to delineate the arms. Then I went on with the legs, I made a division between the left lower arm and the left upper leg. I handled the legs in the same fashion as the arms, working wet-in-wet and trying to get the feeling of form with a single wash. This is a difficult approach and yet the effects can be interesting. I picked out some light areas with a tissue while the first wash was still wet. I left a little white paper at the shoulder to divide the shoulder from the head. There are other areas of white paper which I left unintentionally, but too many bits of white paper break up the form. If I had this painting to do over again, I'd avoid having so many areas of white paper showing through.

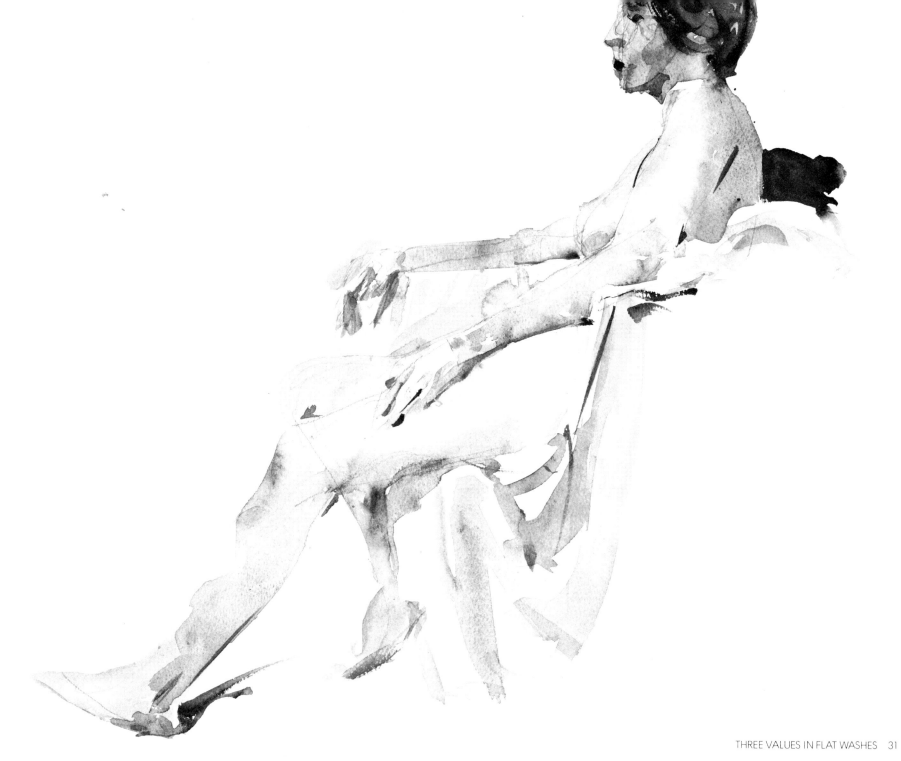

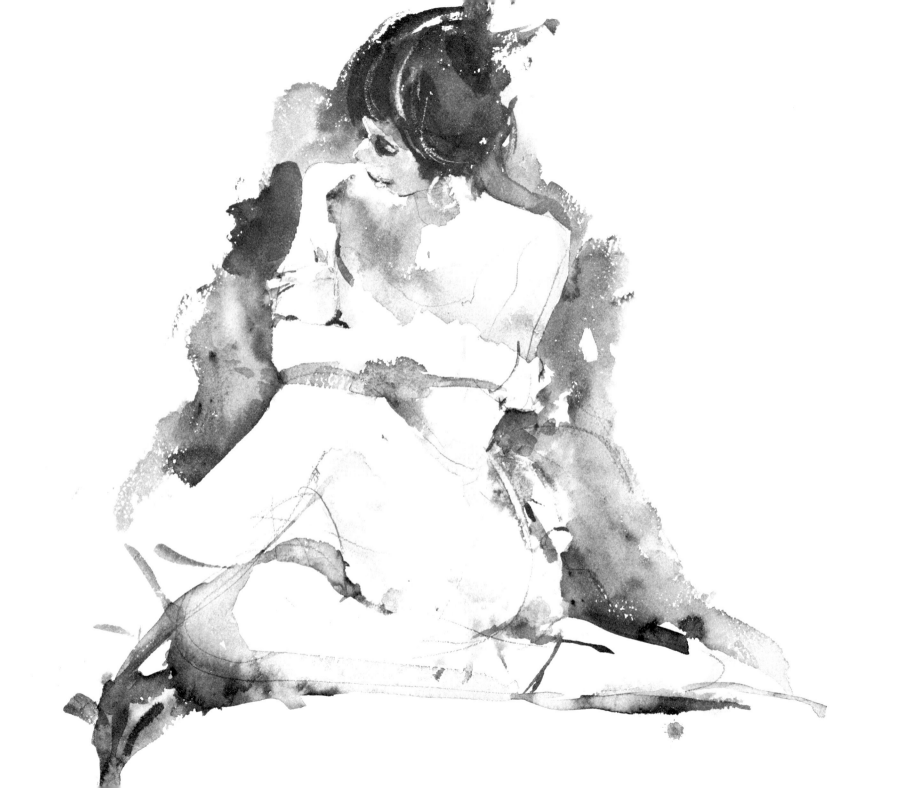

Figure with Arms Crossed (Left), 10" x 12", Arches paper. This is really only a drawing with some shadow shapes added. I used the white paper to stand for the lights. This works pretty well as a study if you have simple but expressive shadow patterns.

Joan (Right), 8" x 10", Bristol paper. I wanted to stress the dark eyes and hair so I allowed the lower part of the face to "get lost" in the mostly soft edges. I used only one or two hard edges in the mouth for some definition.

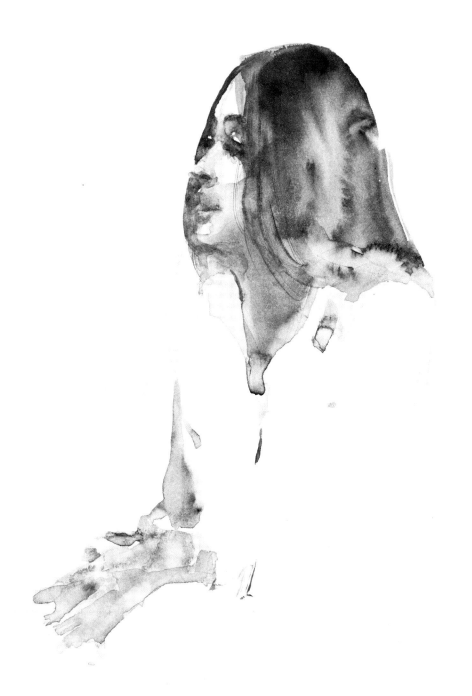

4

GRADED WASH

Now that you've rendered the form of a square object, try a round object. The principles are the same. The only difference is that you'll soften the edges between the lights and darks. Since the human figure is made up of round forms, the ability to blend lights and shadows is important. On the other hand, you needn't become a master at mechanically smooth gradations. Russell Flint, the English watercolorist, did the most exquisite graded washes with the utmost control, yet his work seems vapid and boring in comparison to Winslow Homer's, whose blends are quite clumsy.

You should fill several pages with these exercises. Instead of trying to correct failures, wait and see how water, pigment, and paper work together as they dry. You can't really know what you've done until the wash is dry. One of the great problems with watercolor painting is that by the time you see that you've "goofed," it's too late to do anything about it. Only with experience will you be able to compensate for the lightening of values as they dry—yes, watercolor dries lighter than it looks when it's wet.

For this project, stick to Payne's gray or ivory black, a number 8 brush, pushpins, good quality watercolor paper, a 2B pencil, and a jar of clean water.

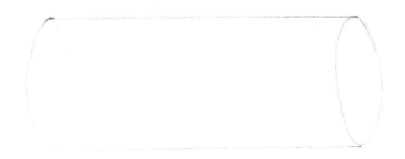

Graded Wash: Step 1 Sketch two ovals, each about 1" high and about 3" apart. Connect the ovals with two straight lines so you've got a cylinder. Erase one of the inside semicircles.

Graded Wash: Step 2 Mix a light wash on your palette, just as you did for Project 2. Load your brush and paint in the whole cylinder, beginning at the top. Run the brush along the top boundary, and work back and forth until the whole cylinder is filled with a flat wash. Allow this wash to dry.

Graded Wash: Step 3 When the cylinder is dry, add another flat wash of a darker value, but this time leave the end of the cylinder untouched.

Graded Wash: Step 4 Now, back to your palette. Mix up a still darker value with quite a bit of pigment. Add just enough water to allow the paint to move smoothly over the paper. Charge your brush from the palette mixture and run it along the top border of the cylinder, leaving the oval at the end untouched. Make this strip about 1/4" high. Working *quickly*, rinse your brush in the water jar, and shake or blot the excess water from the brush. Pass your clean brush along the lower border of the dark stroke. Repeat this stroke back and forth, working downward toward the lower margin of the cylinder. Don't add more pigment or water. It's a good idea to blot the brush with a tissue after each stroke. The bottom strip of the cylinder is untouched by this middle value. Make three or four strokes for the blend. If your cylinder is poor, try again.

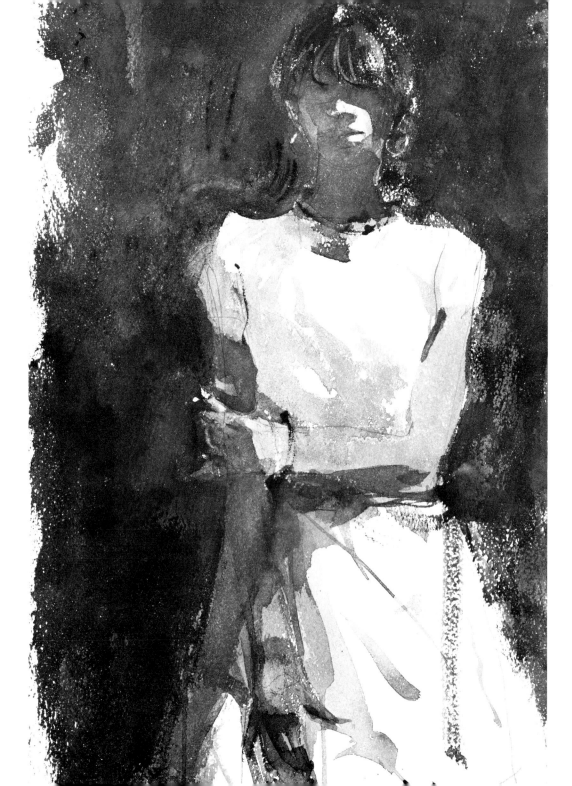

Jamaican Girl (Left), 15" x 10¼", Arches paper. The complexion of the girl and the background are dark. I wanted to contrast the light-struck sections of the face and the dress with the dark surroundings. The pattern of light on the face particularly interested me, and I used the light patterns to explain the shape of the head. The lower section of the face is completely lost, and the background and neck areas have no real division. Therefore there's no reason to delineate all of the boundaries. Some boundaries, such as the boundary on the right side of the neck, can be shown and that's all you need. Let the viewer use his imagination. I used burnt umber and Hooker's green in the background and made the flesh tones gray, using raw sienna and cadmium red light with a little phthalo blue.

Toulouse-Lautrec (Right), 10" x 12", Arches paper. This was done from an old photograph of Lautrec painting. The compact simple form of the body and the effect of light on the head area interested me.

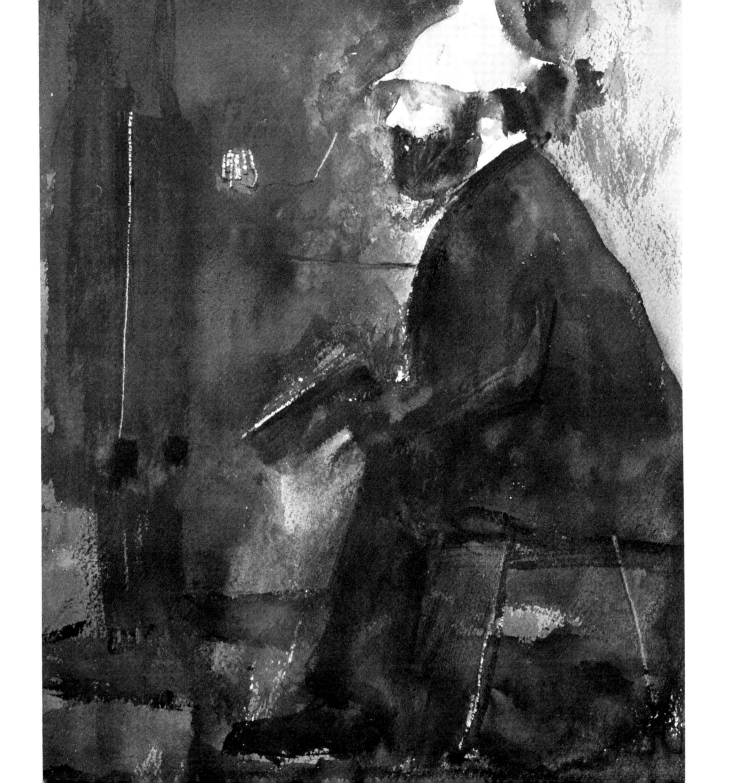

5

WET-IN-WET

Up until now, you've waited for a value to dry before painting a second value. Now try the wet-in-wet technique, painting a second wash on top of the first—without waiting for the first wash to dry. This technique is useful in getting soft, "lost" edges both within the figure and at its outside boundaries. A variety of edges, both hard and soft, is necessary in good figure painting. (This is discussed in detail in Project 7.)

There are two common mistakes in using the wet-in-wet technique. One mistake is making the second wash too wet, with not enough pigment to give it sufficient body. The second wash etches a hole, or balloon, in the first wash. Sometimes balloons can be effective, but try to avoid them for the time being. The second mistake is making the first wash too wet,

a situation which will cause a second wash, even one of good consistency, to spread too much.

Wet-in-wet is crucial to the understanding of watercolor painting. You'll need different types of wet-in-wet effects, using the several combinations I've outlined here. It's a technique used in all stages of figure painting.

I hope you're beginning to get an idea of what amount of water to mix with what amount of paint. It's impossible to tell what's going to happen until a passage dries, so don't meddle with the color once it's on the paper.

For this project, use the same materials you've used before. Pin your paper onto the drawing board, and squeeze out a generous amount of Payne's gray or ivory black.

Wet-in-Wet: Step 1 Dip your brush into your water supply. Give the brush a good shake. With a wash of clean water—or a pale wash of color like the one shown here—dampen an area on the watercolor paper about 3" square. Notice that the wash is "shiny." Wait until this shine dulls. Dip your brush into the pigment on your palette without going back to the water supply and make a mark on the damp area. There should be a definite softening around the edges of the dark color—in other words, you should have a little *bleed*.

Wet-in-Wet: Step 2 Repeat the same process, but instead of waiting for the shine to leave the dampened paper, drop in a darker value right away. You'll get much more bleed this time. Be sure not to work your brush back into the wash after you've made your statement. Let the water, paint, and paper do all the work. Let the color go its own way. You'll only disturb your wash by working into it. Do the same exercise, waiting various lengths of time before adding your second stroke. Remember that your paper will dry quickly in the sunlight or in a dry room; but it will take longer on a damp, humid day with no direct sunlight. Some artists use a hand-held hair dryer to hasten the drying of washes. The dryer also helps "hold" a second wash, preventing it from running too much by drying it quickly. I don't find dryers particularly helpful, but if you have one, it's worth a try.

Wet-in-Wet: Step 3 Lay a first wash of clean water or pale color on the sheet and wait for the shine to leave your paper before adding the second wash. This time, before putting the pigment on the paper, add just a bit of water to dilute the color on your palette. (If *too much* water is added to the pigment, you'll get the balloon effect mentioned earlier. If this happens, use less water.) Drop the diluted color onto the dampened paper.

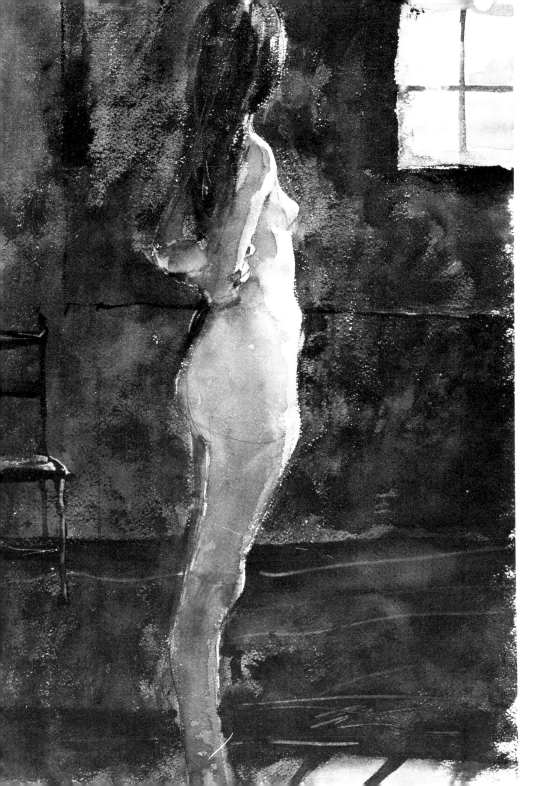

The Window (Left), 15" x 22", Arches paper. The figure was mainly in shadow, with just a small section affected by the light from the window. I might have started off with the shadows, since the figure is predominantly shadow, but in this case I first painted the whole figure with the light values. When the lights were dry, I blocked in the shadows. I wanted the feeling of a dark room illuminated by a single window, but the room isn't extremely low-keyed. There's still definite light so I avoided the tendency to go too dark. It's often a good idea to leave slightly lighter areas adjacent to the light-struck sections of the figure, as I did here. It increases the illusion of space in the painting.

Again, I used drybrush in the hair to get the impression of light. I was careful to delineate the rib-cage with shadow shapes. The arms seem quite short; in fact, they seem too short, but the awkward quality about the pose appeals to me. The arms are mostly in shadow, and there's no real definition. I allowed the left upper arm to blend with the adjacent shadows.

Gray Sweater (Right), 11" x 11", Arches paper. The effect of light in this pose was interesting. The main source of light was coming from behind and to the left of the girl, and it cast a raking light across her face. Many of the shadow areas were "lost," and I tried to get this quality into the painting. I left the features in shadow very simple, and in fact, the only indication of an eye is a small mark I scratched out with my thumbnail while the shadow area was still wet and a small, dark accent that I added later. Instead of value changes in the shadow, I stressed the warm colors in the nose and the cool areas around the mouth and lower part of the face. I used drybrush for the hair, and the bits of white paper that show through work quite well. In other sections I've scratched out lighter indications in the hair with my fingernail. When you have small light-struck areas, you can use the white paper without adding any lighter tones.

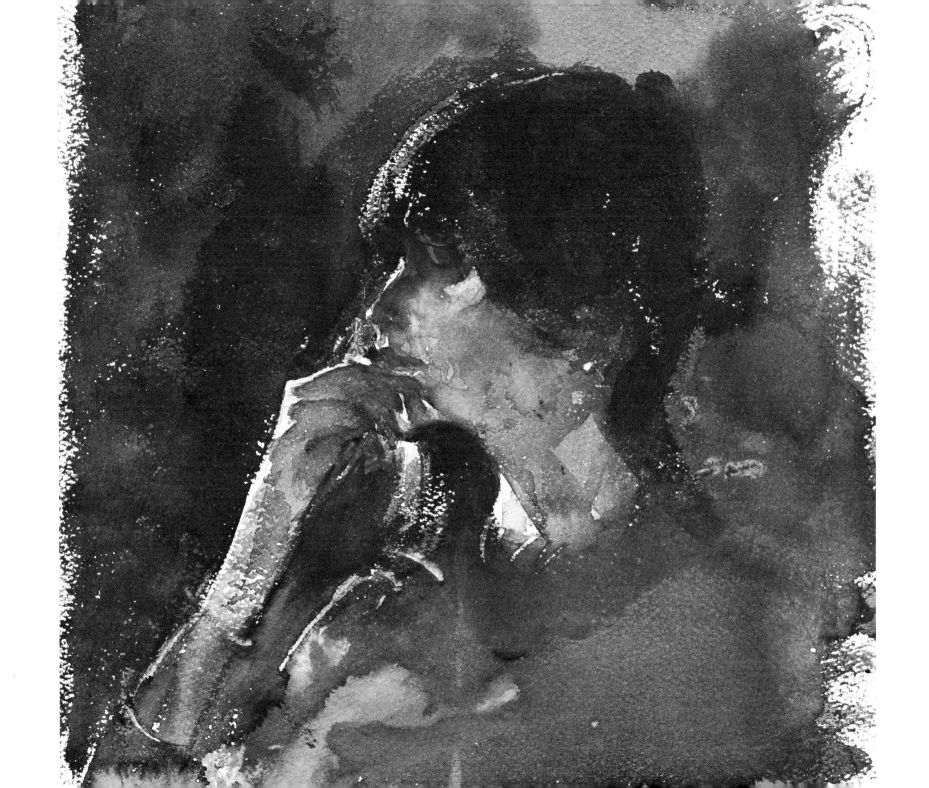

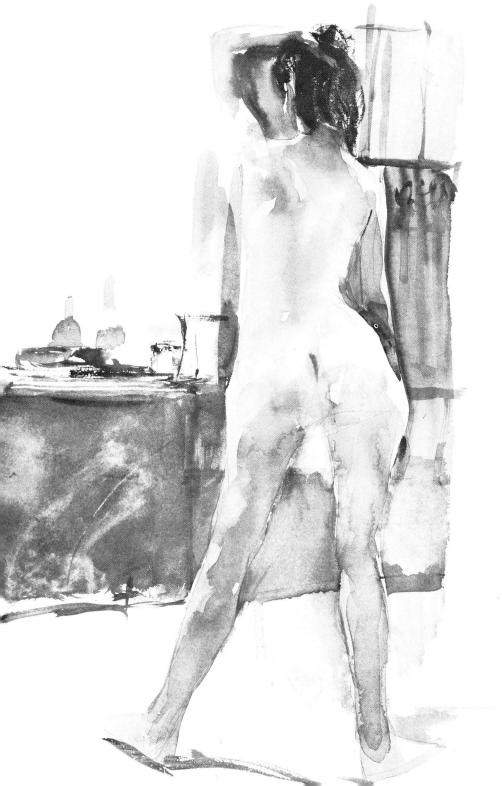

Back View I, 16″ x 20″, 140 lb. Fabriano paper. The model took an extreme pose, throwing her hip out. This caused a rather awkward yet attractive pose. I exaggerated the angle of the lower torso in order to stress this awkward quality.

Back View II, 20″ x 15″, Arches paper. This model had a pearly complexion and that was my main interest in doing this particular study. I washed in the lights first with pure cerulean blue in the torso areas, going to warmer colors in the arms and legs. There was a cast shadow running across the model's back which I added. You have to be careful using cast shadows because they may destroy the form, especially when they go right across a light area such as this. Notice that this cast shadow gets lighter as it goes across. The lightening is subtle, but it's still lighter than the main shadow on the front of the torso. I kept the whole lower back and lower torso simple and definitely lighter than the legs. Not only is the lower torso lighter, but it's also much cooler than the legs. This gives the impression that the lower torso is coming out toward us and the legs are going down.

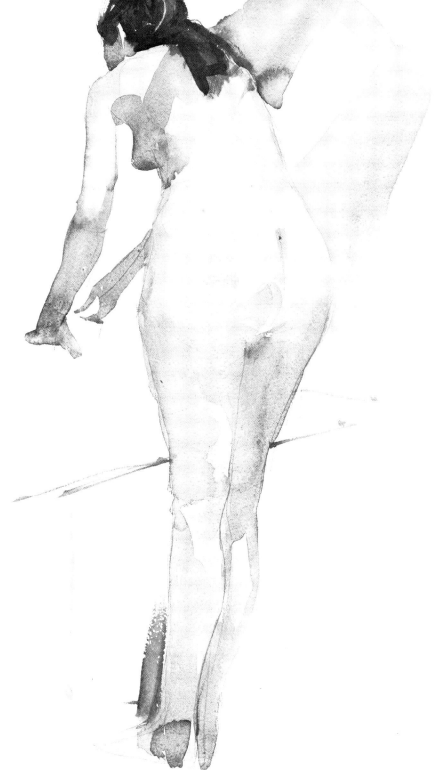

6

DRYBRUSH

Drybrush is a technique in which paint straight from the tube is mixed with little or no water and applied to dry paper. The amount of water you add, if any, depends on the type of paper you're using. Very smooth paper will probably require no water, while a very rough paper, with lots of "tooth," will demand some water to make the paint workable. Drybrush usually means skimming the brush across the surface, hitting the "high points" on the paper and leaving the "valleys" between untouched.

This technique creates one of the most versatile textures in watercolor. Drybrush can suggest detail and definition without actually painting that detail and definition. This is useful in painting hair, clothing, backgrounds, and—sometimes—skin tones.

For this project, your materials will be Payne's gray or ivory black, a number 8 round sable watercolor brush, palette, pushpins, fairly rough textured paper, drawing board, and a jar of water. Squeeze out a pile of Payne's gray or ivory black on your palette. Dip your brush in the water, and blot it thoroughly with a tissue to make certain that your brush is only damp, not wet.

Drybrush: Step 1 Dip the brush into the undiluted pile of paint on the palette. Now you're ready to make a stroke. Hold the brush at a 45 angle, the wooden end of the brush pointing in the direction of the stroke you're going to make.

Drybrush: Step 2 Make a quick, continuous stroke. Don't dab at your paper: make your stroke decisive and bold. You shouldn't have a solid line of tone, but rather a broken, "pebbly" stroke with white paper showing through in spots.

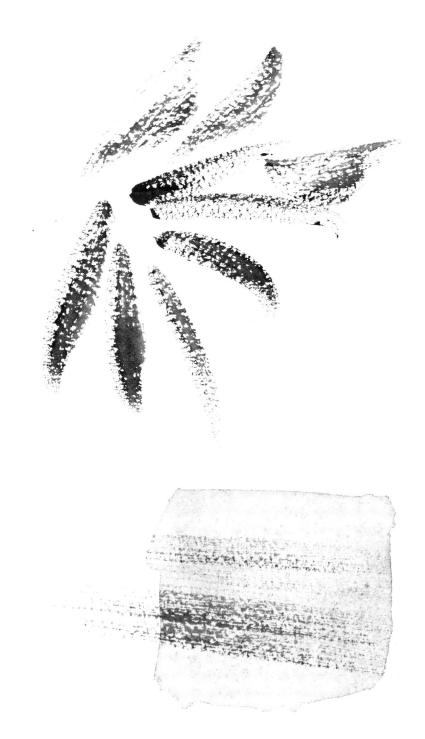

Drybrush: Step 3 Repeat the process, but this time practice making short, quick strokes going in various directions. No matter what direction your stroke takes, it's easier if you always hold your brush at the 45° angle with the end of the brushhandle pointing in the direction of the stroke—in the direction which you're going to pull the brush.

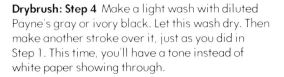

Drybrush: Step 4 Make a light wash with diluted Payne's gray or ivory black. Let this wash dry. Then make another stroke over it, just as you did in Step 1. This time, you'll have a tone instead of white paper showing through.

Drybrush: Step 5 Now try merely shaking your brush, not blotting it, before dipping it into the paint on your palette. The resulting stroke on the paper should be wetter, but it should still have all the characteristics of drybrush. If the stroke is continuous, with no paper showing through, give it a harder shake so that it won't be quite as wet.

Drybrush: Step 6 Finally, add some water to the pigment on the palette, and stir up a mixture. Rinse your brush and blot it or give it a couple of very hard shakes. Dip it into your mixture. *Blot your brush lightly or shake it again* and make a stroke. The result should be a drybrush stroke in a lighter value. This is the hardest step in this project because you're adding extra water—so it may take more practice. The final blot or shake is the crucial stage. If you don't get rid of just the right amount of excess moisture, you'll have trouble.

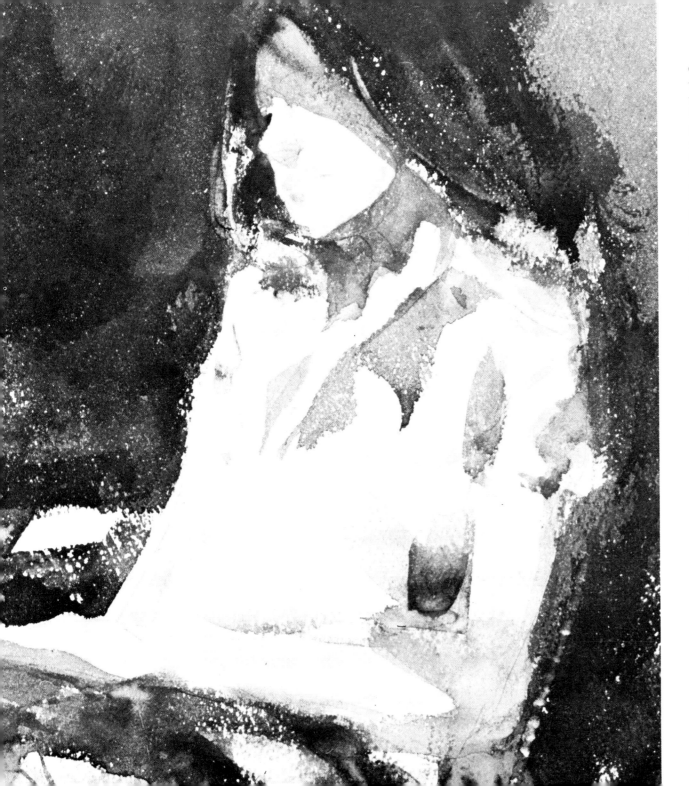

Girl Reading, 15" x 15", Arches paper. The skin tones are washed out and close in value to the white shirt, but even so, there's a difference, and I established this difference in the beginning of the painting. I painted in all the skin tones with light values and allowed them to dry before adding the shadow shapes. While the shadow shapes were still damp, I painted in the hair so some of the soft edges that are important in shadow would happen. The background is mainly burnt umber with a little blue added. I also used Hooker's green and burnt sienna. The shadows in the shirt were predominantly blue, with a little umber mixed in to lower the intensity. I left the shirt as simple as possible because the white paper is effective in communicating the feeling of sunlight. Detail shown at left.

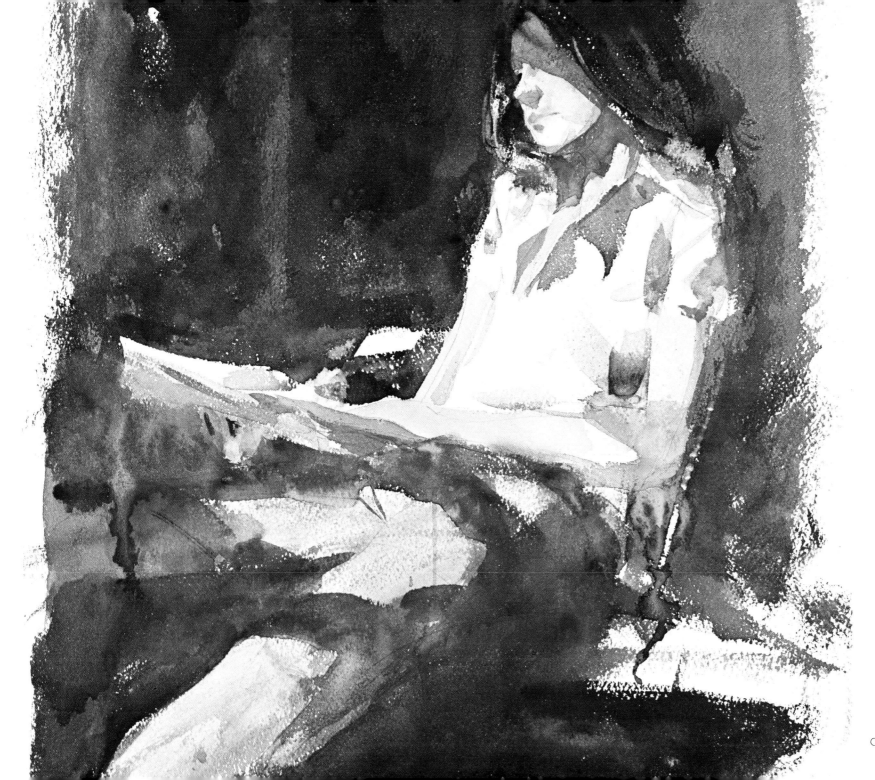

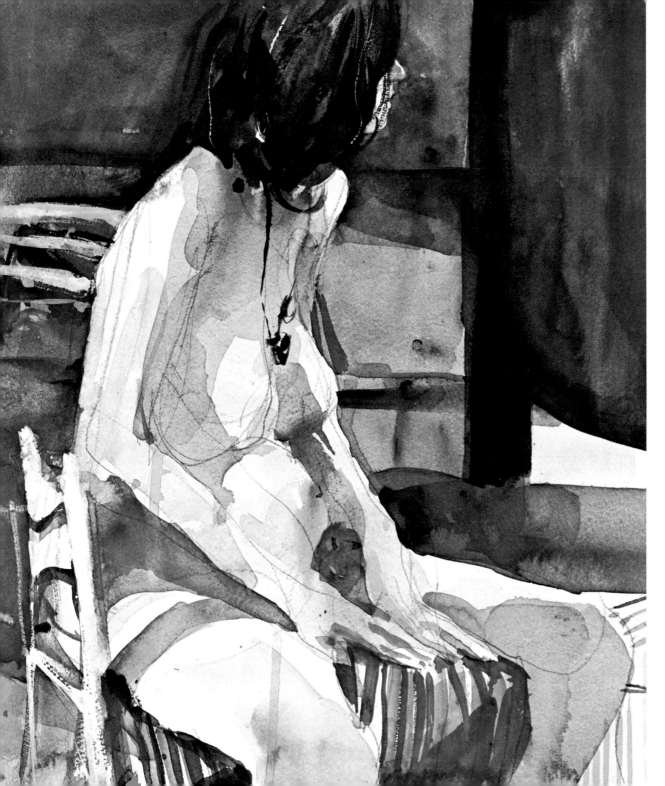

Seated Model (Left), 15" x 12", Fabriano paper. This painting was done in a sketch class. I paid a great deal of attention to the relationship of the figure to her surroundings. I tried to think of the figure as an area of light and as a shape surrounded by other shapes. As in most of the sketch class paintings that I've done, the colors are stronger and more vibrant than in the paintings I do from sketches or photographs. The use of strong reds is obvious here. There's also a roughness which comes from working quickly and spontaneously. I think this roughness is attractive, and I like this picture's rather crude, unfinished quality. I was also interested in the strong horizontal and vertical shapes which lead the eye through the picture. Notice how the dark shape on the right helps balance the figure. I've tried to contrast patterned areas with broad, simple, plain areas. Notice the use of stripes in the chair and in some areas of the background.

Sandra (Right), 15" x 20", Arches paper. This was a drawing first, but when I got back to my studio, I decided to add color. I used much darker pencil work than I normally do. This was a Wolff pencil which produces rich linear work. I made no real attempt to establish the local color of the flesh. I merely blocked in some dark areas in the figure. There was no particular light source in mind; I was just interested in the pose and how that pose created a shape in relation to its surroundings. I carried the red background over into the shadows on the left lower leg. This is much too warm for the flesh areas, and generally you shouldn't confuse a color in the flesh with a color in the background. However, I felt that the figure needed some strong color note, so I used the rich red.

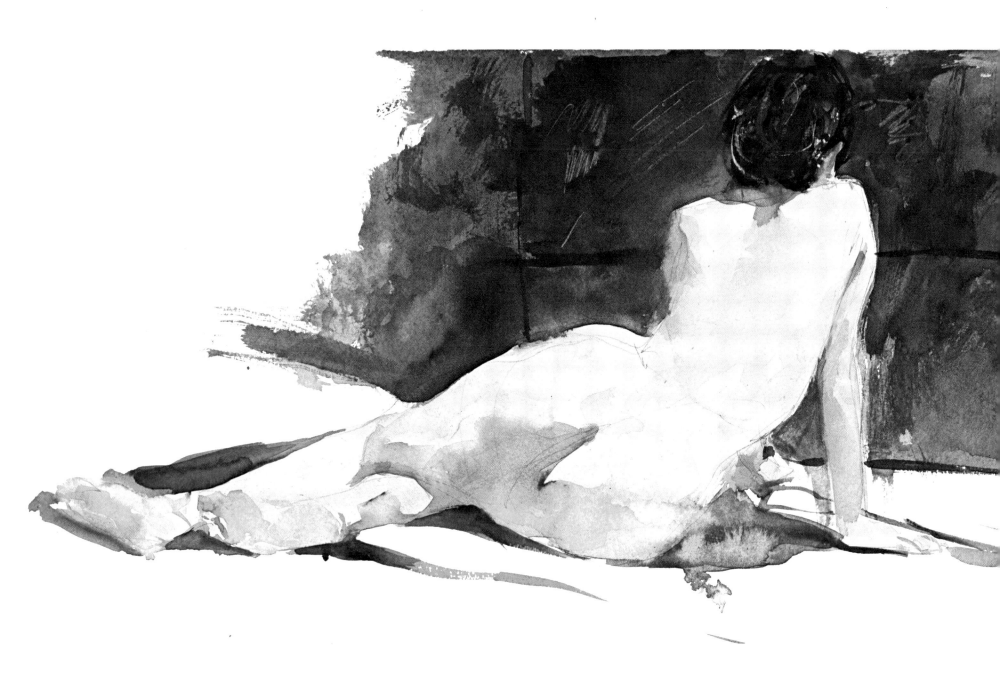

Jennifer (Left), 15" x 20", Fabriano paper. This model has extremely good shapes, and the form of the lower torso and the curve of the upper torso impressed me. I was also interested in the large and articulate shadow shapes. All of the lights are high-keyed, with only a slight indication of middle values in the back, but because the shadows are definite and quite a bit darker, the light areas function nicely. My colors here were the usual cadmium red light, cadmium yellow pale, and cerulean blue. In the shadows on the figure, I used cadmium red and raw sienna. The colors are subtle in most of the figure, although there's a definite cooling in the lower torso and back. The arms are quite warm. I used a little pure red up in the neck to add a color accent to the figure. Don't be afraid if some pure color happens; it can often be a nice touch.

Standing Figure in Sunlight (Right), 18" x 15", Arches paper. I like the mysterious quality of the face. The girl's hair kept most of the face in shadow, and only the nose and a little section above the eye picked up any light. The flesh tones are neutral, especially the torso areas which are mostly cerulean blue. I did the background with burnt umber and phthalo blue with a little alizarin crimson added. The wall is rough, so I used drybrush to create a pebbly effect and then applied some shadow work. My colors were raw sienna and some burnt sienna with a little blue added in the wall to the right of the model. In the figure I left hard edges to accentuate the angular quality of the subject. With my fingernail, I scratched out a few lights in the hair, while it was still wet. The hair and the adjoining skin tones have no clear-cut division because I painted the hair while the skin was wet, and then while the hair was still damp, I added the background on the wall adjacent to the hair. The colors in the hair were burnt sienna and raw umber. I added a little drybrush using just one or two careful strokes to the hair away from the light.

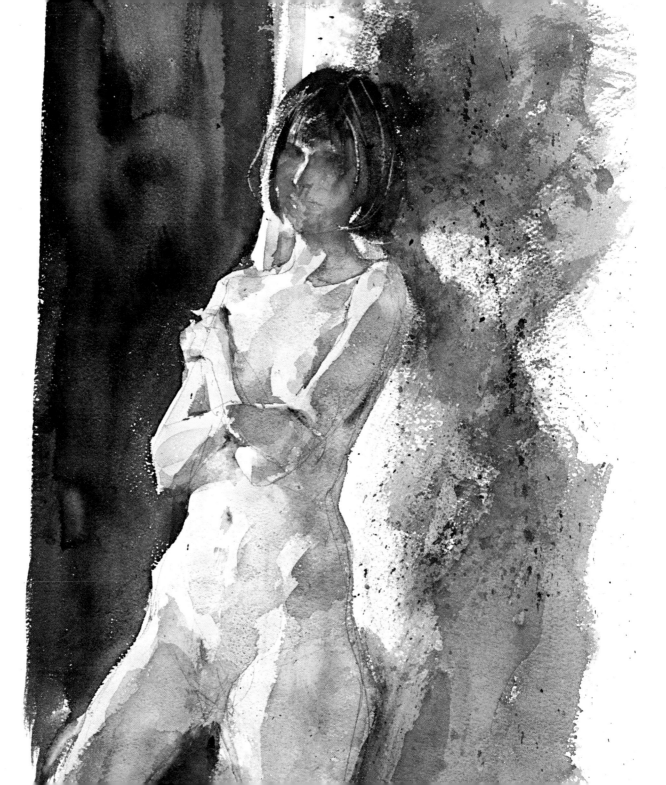

Red Background, 13" x 20", Fabriano paper. This model was against a brilliant red background which I painted with alizarin crimson. The cool upper torso contrasts with this red. The legs become warm again down toward the knees, but the torso is mainly cerulean blue. The model is almost completely in shadow, but because I painted the subject in a daylight situation, the shadows are diffused. There was a single light source behind and above the figure which I indicate with white paper. The modeling within the shadow is subtle, and I depend upon the color changes to give the major feeling of form.

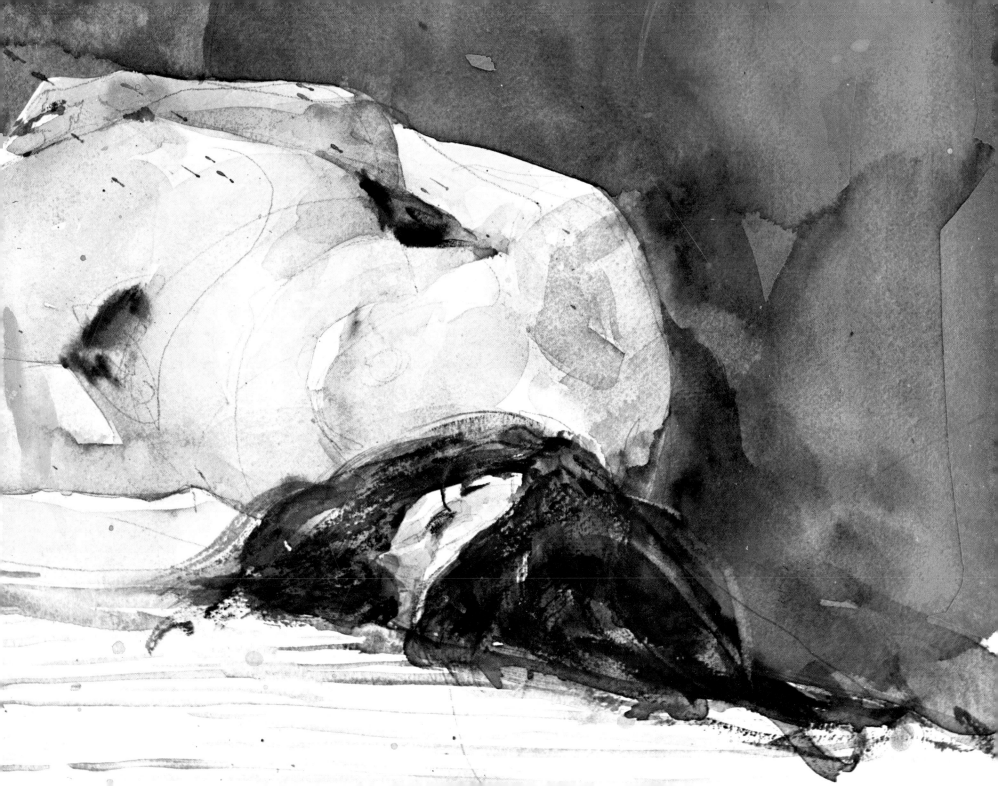

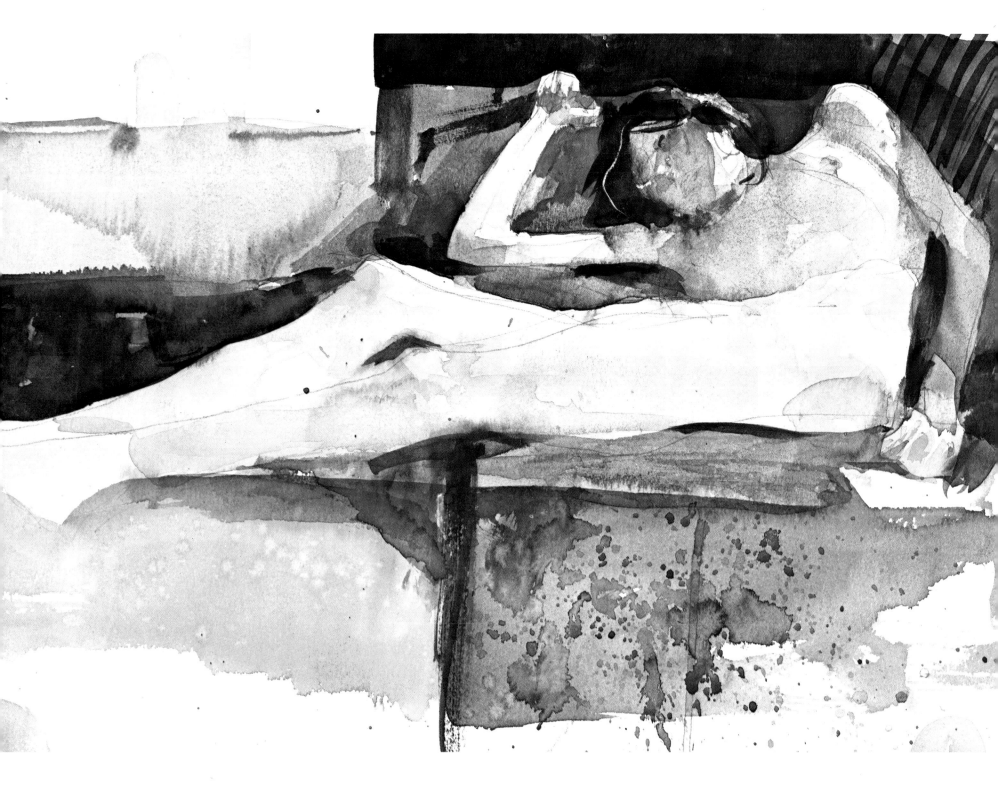

Saturday Morning (Left), 11" x 22", Fabriano paper. This pose was difficult, and I had trouble with the shapes because of the great length of the upper leg. It still doesn't look right, but the girl did have extremely long legs, and because of the fore- shortening of the upper torso, they seemed all the longer. The upper torso and head are lost in shadow with just a few light-struck areas to indicate the form. There's more going on in the shadow areas which I started to indicate, but I decided that the simplicity of the shadows was more attractive, so I washed out the small details with tissue. The area under the right upper arm has been restated with a dark. There's a certain loss of freshness when you work into shadows, but don't let this stop you from simplifying an area which has become too cluttered or too busy. The light was changing quickly, but I wanted to get the sunlight hitting the shoulder and left breast and also the left side of the face. I was going to leave the hip area much lighter, since it was also struck by sunlight, but it made the construction of the figure look strange, so I cut down on this contrast, leaving the value difference between the hip and upper torso closer than it actually was. Detail shown at right.

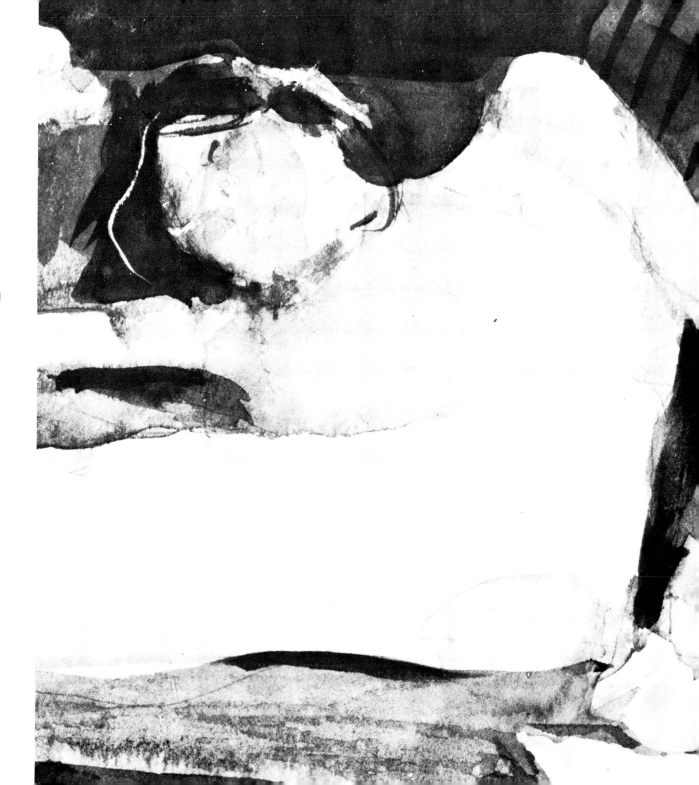

7

EDGE CONTROL

Edge control is the technique of making hard and soft edges where they belong. this sounds simple enough. Unfortunately, before you can control edges, you must be able to control watercolor—and this is by no means easy! The things you've learned in the previous projects are vital. If you've mastered drybrush, wet-in-wet, and paint consistency, you won't have any trouble with this project. If, on the other hand, you're not satisfied with your work in these areas, go back and practice some more. So, with this word to the wise, let's get on to edges!

Edges in shadow are less distinct than edges out in the light. Look at some object in shadow. Now look at another object out in the light. The object out in the light has much more definite edges than the object in shadow has. Its boundaries are precise and clear-cut while the boundaries of the shadow object are fuzzy and soft by comparison. This seems simple enough until it comes to painting a picture. Then almost every student will paint all edges hard whether they're in the light or not.

Start now looking for hard and soft edges, even when you're not painting. When looking at any object, analyze its edges. Notice the obviously hard, crisp edges facing the light, but notice also the more difficult to analyze edges which are somewhere in between the obviously hard and the obviously soft shadow edges.

In a simple sphere, the transition from hard to soft, from light to shadow is clear. Notice also that when you focus your eyes at a certain object, all the surrounding areas go out of focus. Their edges get softer. This is very important to remember when you're painting. Your eyes can't focus equally on a whole room so why should you paint a whole room with equally hard edges. Some parts of the room should be relatively out of focus, just as some parts of a figure should be relatively out of focus in your painting.

Now let's get on with the practice work. For this project, you'll be using exactly the same materials you've used in all previous projects.

Simple Sphere. Soft edges are used within the form of a round object when one section is in light and another section in shadow. In a square object, the division between light and shadow has a hard edge.

Edge Control: Step 1 Mix a light value on your palette, and make a rectangle about 1″ x 3″ with your brush. Let this dry completely.

Edge Control: Step 2 Back to the palette. Mix up a darker value. It doesn't matter how dark, just as long as it dries darker than your first wash. Now make a wash exactly the same size as in Step 1. Place it right alongside and slightly overlapping the first wash. Allow this to dry. The two washes should form a crisp, hard edge. This procedure will be the same whenever you want a hard edge, even in much more complicated subjects. It's very simple!

Edge Control: Step 3 Make a light wash, and repeat the procedure in Step 1, but this time you don't want the wash to dry before adding the second wash, so hurry back to your palette.

Edge Control: Step 4 Mix a darker wash quickly, making sure it's made of a generous amount of pigment. Remember the wet-in-wet project? This is the same procedure except, instead of dropping the second color *into* the first wash, you'll paint it right *alongside* the first. Taking the damp, not-really-wet brush from the palette, make the second wash the same size as the first and overlapping the first. You should have a soft edge between the two rectangles. However, if you've waited too long, the first wash is now dry, or at least not sufficiently damp to make a soft edge.

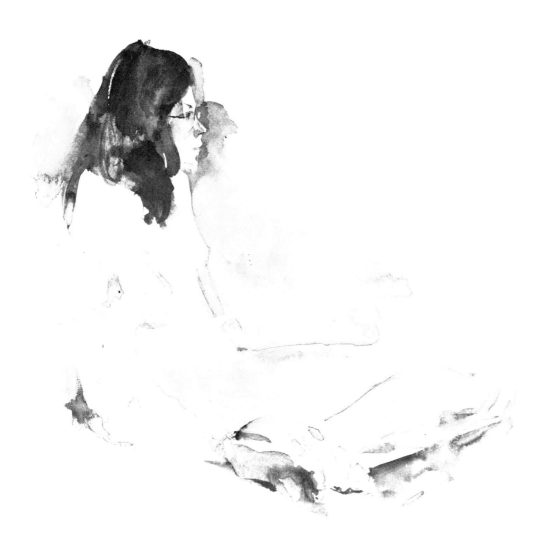

Mary I (Left), 15" x 20", Fabriano paper. There is no light and shade since I did this picture at night, and the studio had only diffused lighting. Nevertheless, the color was very evident, and I used the color to give the impression of form. I allowed the reds to dominate in the legs, with much cooler, lighter color in the torso areas. I spent quite a bit of time in the drawing stages trying to delineate the character of the head. In the painting stages, I used delicate washes.

Sketches of Peter (Right), 15" x 20", Fabriano paper. My son was drawing and reading on my studio floor, so I made these quick, rough notes. I sketched with a ballpoint pen first and then added washes of Payne's gray. Making studies like this is good practice, and you should try it as often as you possibly can. You mustn't expect your finished product to be particularly handsome, but don't worry about this. The sketches have a certain charm, even though they aren't as accurate as you might wish them to be. It makes the job easier if you have large, simple shadow shapes to work with. In most of these, the head is merely a dark mass, and I was able to use the dark shadow shapes on the torso and finally the dark mass of the trousers. Whenever you get into small details and don't have the big shadow shapes to work with, watercolor figure painting becomes a much harder job.

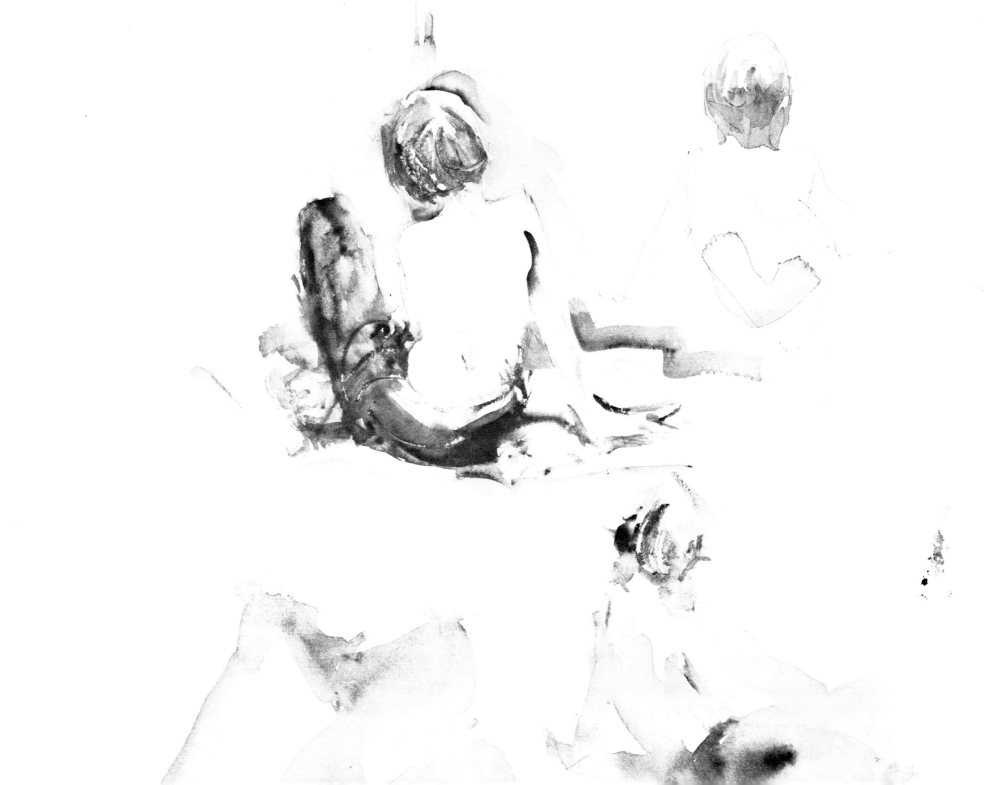

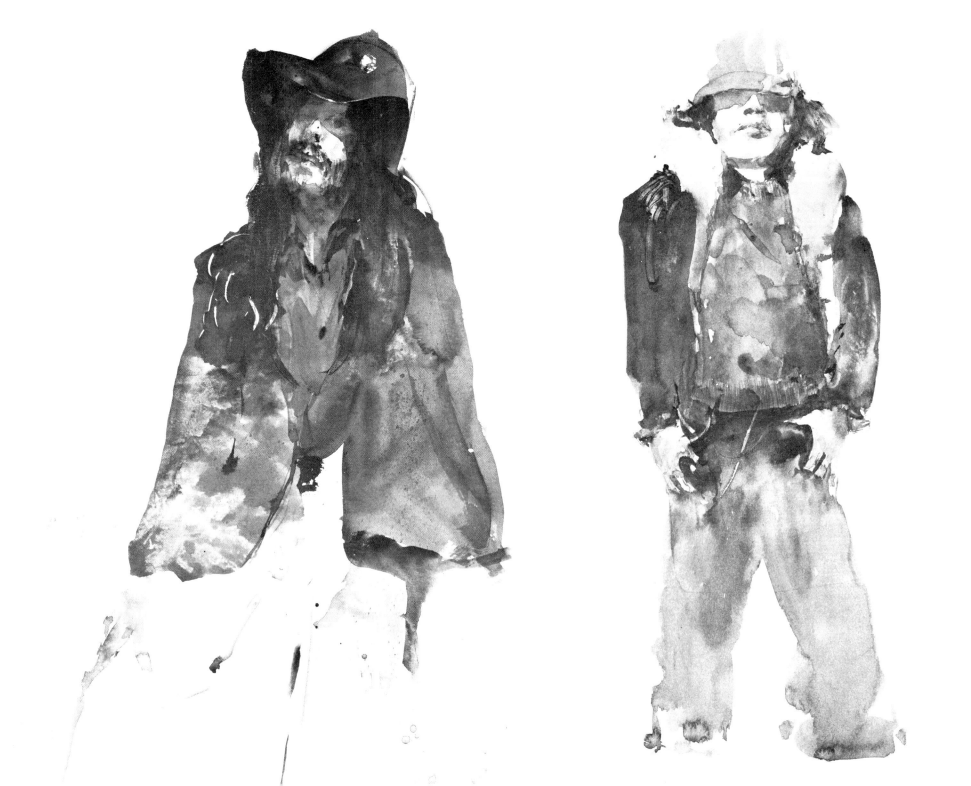

Red Hat (Far Left), 20" x 15", Arches paper. The boy friend of one of our models posed for this picture. He had an involved costume, and although the jacket was filled with intricate patterns, I just didn't have time to explore them. I was more interested in the way he was holding his head and in the effect of the light on his face. I washed in the hat with alizarin crimson and some of the alizarin crimson got down into the flesh tones. The whole area of the face and hat was vague at first, with many soft edges since I was working so quickly, wet-in-wet. Alizarin crimson is a tricky color, and it's much harder to use in the wet-in-wet areas; it wants to dominate. When my first wash was dry, I began to pick out and delineate some of the divisions between areas, but the divisions between the skin tones, hair, and hat still have little definition. I indicated his scraggly moustache with a light wash, articulating it more with drybrush. The shirt was a brilliant blue, and this color reflected up into his chin, causing a cool shadow area.

Leather Jacket (Left), 8" x 10", Bristol paper. I liked the stance of this figure with his hat coming down and his collar going up. The hard paper is fun to work on. Some "happy accidents," combined with finger prints and scratching with a brush handle and fingernail, suggest textures.

Henley (Right), 8" x 10", Bristol paper. Henley is a lobsterman on Monhegan Island, an intelligent man with a keen interest in the world around him. Since the lobster season on Monhegan runs from January to April, the beard is for warmth not appearances.

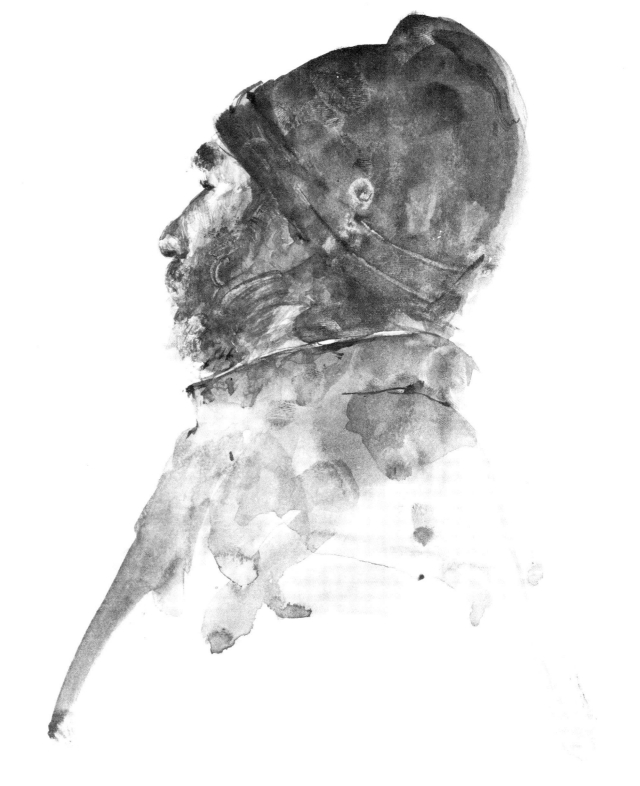

8

SILHOUETTE FIGURE

The purpose of this project is to help you think in terms of large areas and to help you control these large areas without resorting to small brushes and fuzzy, small strokes. This figure will be described with large, simple masses, and the arms and legs will be indicated by single strokes whose width is dictated by the amount of pressure put on the brush. To help in this, we're using no boundaries or outlines as guides. This will avoid the tendency to fill in areas with small, fastidious strokes.

In figure painting, think of the form as a golf course, where every extra stroke counts against you. See if you can paint the figure in eight strokes or less. Pay attention to shapes, and try to get as close as possible to the human silhouette, but don't worry if your silhouettes aren't completely accurate. It's more important to get the feeling of moving the brush

freely. With practice, the shapes will improve. Also remember that corrections can be made—but we ll discuss that in a later project.

To make long, flowing masses, control the width of the stroke to conform with the contours of the figure. The actual narrowing and widening of the stroke isn't difficult, but controlling the hand, to make the width of the stroke change at just the right place, isn't so easy. It will take a good deal of practice.

For this project you'll use the same materials that you've been using, but let me advise you to have a good number 8 brush that will point nicely when dampened. I suggest a Winsor & Newton professional-grade number 8 brush for this and the remaining projects. The job is so much more difficult with a cheap or tired brush.

Silhouette Figure: Step 1 Charge your brush from the palette. Make sure that the paint consistency is good, and paint a single stroke about 5″ long. Don't press down too hard, but hard enough to make a stroke about 1/2″ wide.

Silhouette Figure: Step 2 Reload your brush and make another stroke, beginning just as you did in Step 1. This time, however, vary the pressure on the brush. After beginning the 1/2″ wide stroke, slowly but steadily increase the pressure on the brush until the stroke becomes about 3/4″ wide; then slowly decrease the pressure until you have a very thin section about 1/4″ wide. Repeat this process several times. These first two steps are stroke practice.

3

4

5

6

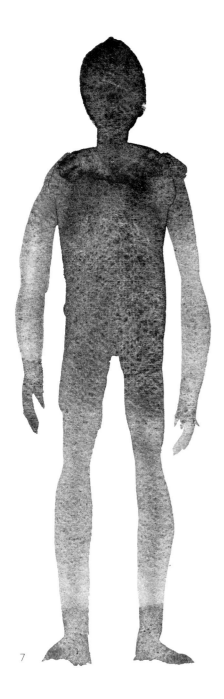

7

Silhouette Figure: Step 3 Now let's try a figure. After recharging your brush, start with a simple stroke about 3/4″ wide. This will stand for the head. You might have to jockey the brush a bit, but *don't* let the brush actually leave the paper. You want to use as few strokes as possible, and your brush is still making the same stroke as long as it doesn't leave the paper. After about 1″, start letting up on the pressure. This narrower part will stand for the neck. Continue the stroke down into what will be the upper back for another inch. You should now have the head, a thinner indication for the neck, and part of the shoulders. If you've got enough paint in your brush, backtrack up to an approximate shoulder line, and indicate one of the shoulders. Make the stroke over from the neck about 1″ or a little less. Don't worry about proportion.

Silhouette Figure: Step 4 Recharge your brush before going on to the other shoulder, but work quickly and pick up the first wet stroke where you left off, continuing back across the torso to indicate the second shoulder. Block in the upper and lower torso. Recharge your brush again if you need to. The silhouette may be irregular, but don't worry if your first attempts don't look very human.

Silhouette Figure: Step 5 You're ready to block in the legs. Your practice work in varying the pressure on the brush will come in handy here. Make the upper leg with a stroke about the same width as the head. As the brush proceeds downward, gradually lessen pressure on it, not too much, but by the time it gets to the knee, there should be a definite narrowing of the stroke. The upper and lower leg will each be about 2″ long. Now start increasing the pressure to indicate the calf muscle in the lower leg, then gradually decrease the pressure for the ankle, and indicate the foot with a small triangular form.

Silhouette Figure: Step 6 Do the same thing for the other leg.

Silhouette Figure: Step 7 Finally, do the arms and then you're finished. Go back to the shoulder (either one) with a loaded brush. Start down at the end of the shoulder painted in Step 2; don't continue the width of the shoulder any further. The stroke narrows to the elbow; then once again it widens but tapers quickly down to the wrist. Repeat the same kind of stroke for the other arm. The arms should each be about 2″ long.

Silhouette Figure: Variations Here are three more figures for you to try. Remember the work should be done without pencil outlines, so do your versions of these three silhouettes, starting right off with value masses.

Ann, 10″ x 20″, Arches paper. I did this drawing from a model, and I was going to leave it as a drawing, but when I got back to the studio, I decided to add a few color indications. I was interested mainly in the strong shapes, both in the face and in the arms and legs. The figure is freely sketched in. I'm not strictly accurate in terms of the girl's shape; the arm, for example, isn't literally correct, but I like the bony quality here. Notice how the lower left arm continues on into the left leg. I always try to relate various parts of the body and think of the whole body when I'm drawing a single section, rather than just that single section by itself. When I did add the color, I didn't adhere to the boundaries carefully. Pencil work should be only a guide and aid to your color work; it should never be something that you have to stay within.

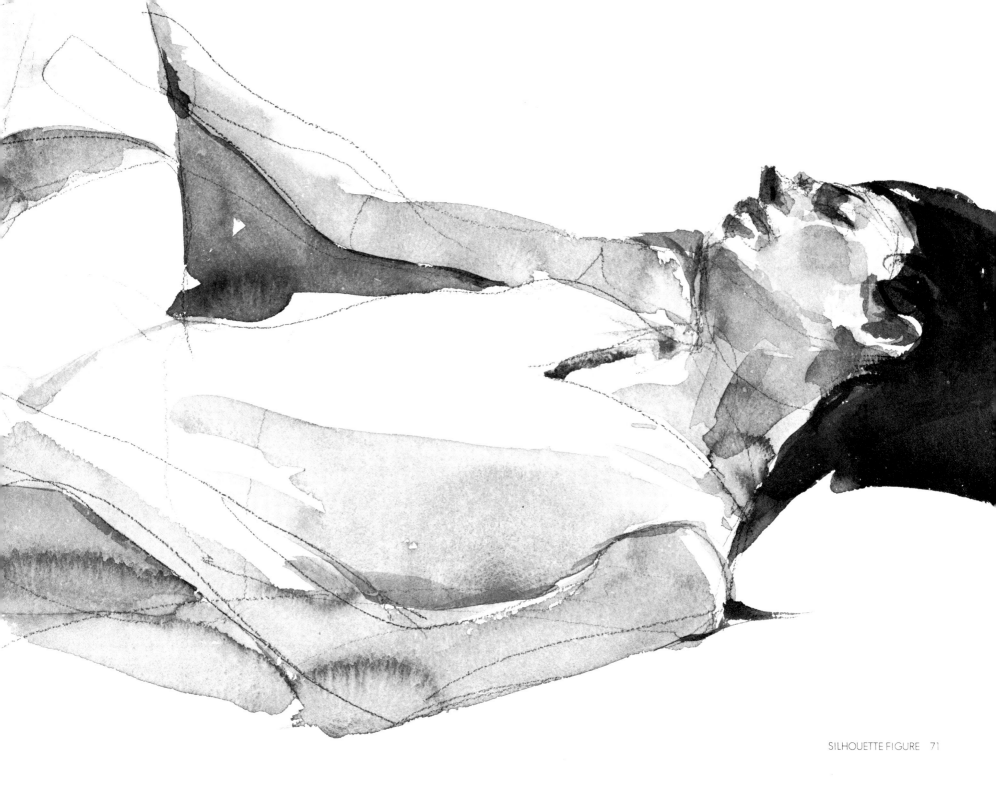

9

GESTURE

In this project you'll again use wash silhouettes, but this time you'll go a step further, using action poses rather than a simple standing figure. You'll use longer strokes that encompass more of the figure. The emphasis will be on conveying an action or gesture, rather than rendering the exact form.

In any action, the whole body is involved. When the arm is thrust upward, the head and torso move to the side. When a football player kicks a ball, almost every part of the body is affected; the torso goes back, and the head and arms come forward to balance the action of the torso.

A puppet is an example of a figure that doesn't move as a whole. When his head or arms move, his body remains stationary and unaffected. Therefore the movements look disjointed and unrelated.

To show the relationship between the parts of the body you're painting, try to paint several sections of the body at the same time. Literally this isn't possible, but you can begin a stroke that describes one section and continue the stroke into other sections. The parts of the body you combine into one stroke will depend on the pose; but in general try to include just as much as you can in a single stroke.

I want you to experience the idea of a fluid, continuous stroke. Don't try to correct mistakes. Expect to make some errors and clumsy figures. The point of this project is *not* to suddenly arrive at beautifully formed figures, but just to get the idea of the interrelationship of the parts of the body.

What should you use for models for your practice? If you're fortunate enough to have a sketch class with a live model and quick poses, that's fine; but first I think you should get some practice, and photographs are the natural answer. There are several good books with nude action poses. The sport pages of your newspaper and most magazines also have plenty of material to keep you busy. I don't mean to imply that working from life isn't the best of all references. It has a special quality that's impossible to describe; work done from life always seems to *have* more life. But do get some practice under your belt so you won't be at sea when confronted with a model that doesn't stay absolutely motionless.

As you begin these steps, think of the relationships that unite the figure into a flowing, graceful form. Your materials will be the same as in all of the projects. Use a full (22" x 30") or a half (15" x 22") sheet of good quality paper.

In this project you're going to do a walking figure. Study and analyze the pose. Make sure you understand what the figure is doing before putting pencil or brush

to paper. Notice the relative position of the arms and legs to one another and to the head and torso. The body isn't directly under the head but is thrust forward.

Gesture: Step 1 Establish the head form with your brush. Then draw a vertical line down from the head, starting at the ear. This line should come close to the back of the waist and hit the front of the right knee, providing a guide. Sketch it in very lightly.

Gesture: Step 2 Since the body thrusts forward, the left leg is a natural extension of the front of the torso. Make your first stroke describe both these forms: the front of the torso and the left leg. It's better to exaggerate the action rather than understate it. The stroke should curve forward as well as down. Make this an easy, curving line down to the foot. It's not crucial how the curve describes the leg; the important point is that the stroke describes the thrust of the torso. If you get this point, the rest of the figure will fall into place.

1

2

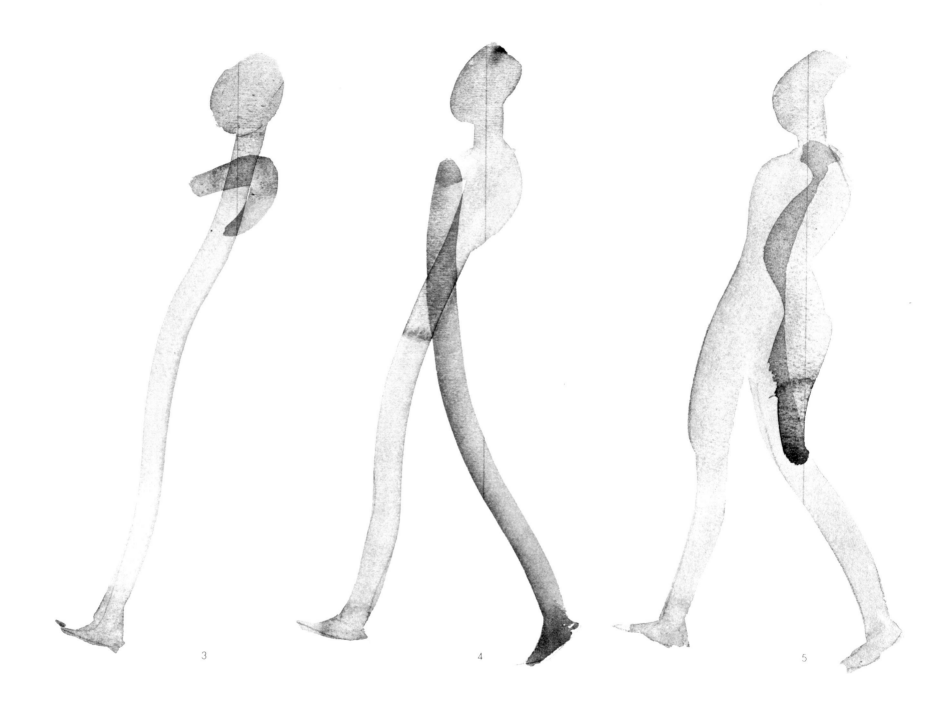

3

4

5

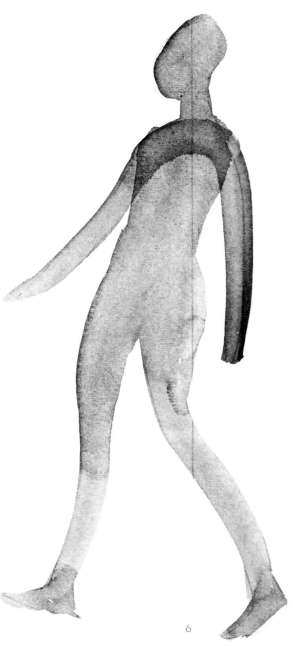

6

Gesture: Step 3 Where is the shoulder line placed? Although there's no definite distance from the chin to the shoulder line, in this case, assume that the front of the neck is about a fourth of a head-length long. The shoulders aren't level. Make the shoulder section to the left of the neck longer than the shoulder section to the right of the neck. Remember that the shoulders are equal in length only when the figure is seen from the front. Continue the stroke, "jogging" down from the end of the shoulder to start massing in the upper torso.

Gesture: Step 4 Beginning at the left end of the shoulder, make a free, curving line to describe the right leg. This stroke ties in the upper torso with the leg, showing the relationship between these two areas. Make the right foot lower than the left foot.

Gesture: Step 5 Finish massing in the upper and lower torso. The major decisions have been made, and the big relationships have been created. This is really just filling in; however, try to get as close to the correct shape of the torso as possible.

Gesture: Step 6 Now come the arms. Start with the left hand and continue in a single stroke up to and through the shoulders and down the right arm. The single stroke shows the relationship between the arms.

Gesture: Variations Here's an unedited sheet of action figures. Some of them are better than others, and one or two are failures. Make several attempts at each one just for practice.

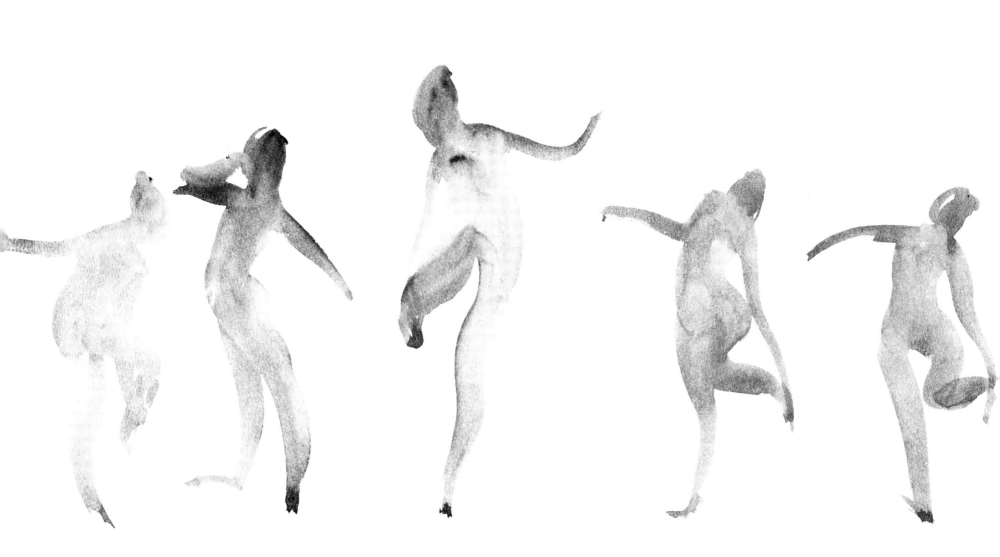

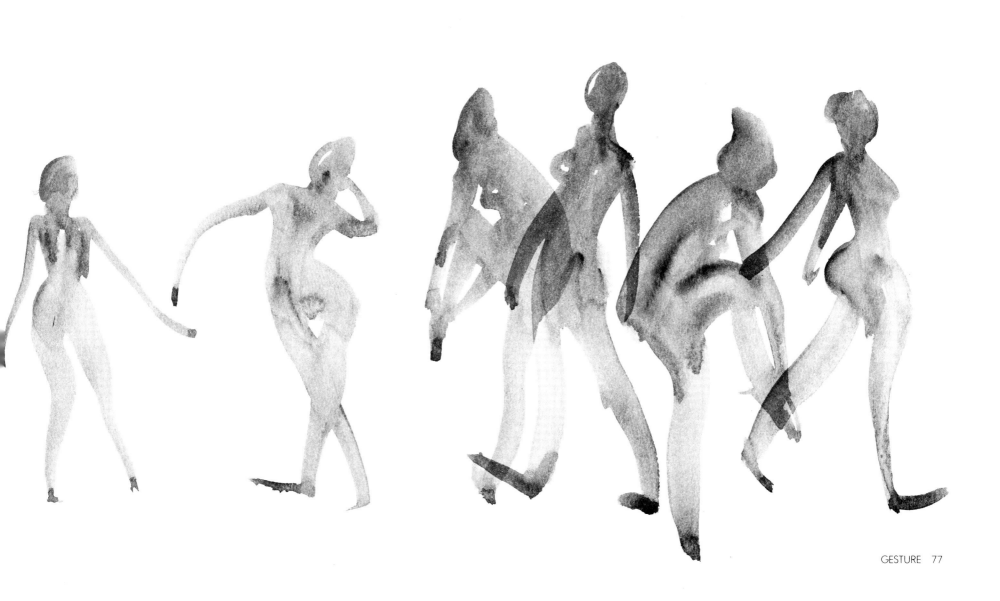

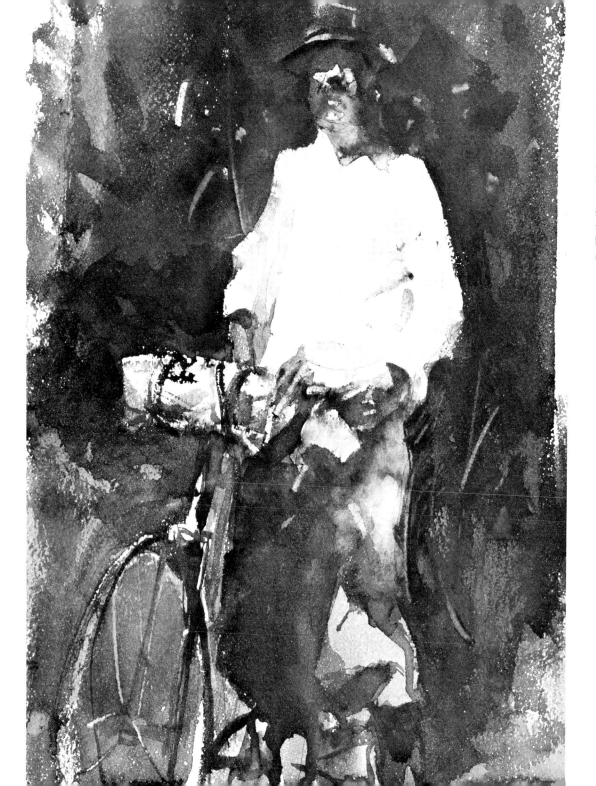

Bonnard and Bicycle, 15" x 11", Arches paper.
This was done from an indistinct old photograph.
It was interesting to work from because so many of
the areas were lost. Almost all of the shadow areas
were blended in with one another. The areas of
the face in shadow are completely lost, so I kept
the values high-keyed. I wanted the effect of re-
flected light in these shadows. I used white paper
in the light-struck sections of the face with some
small drybrush indications to keep them from get-
ting too washed out. I used an almost pure phthalo
blue on the shadow under the head to describe the
neck of the sweater.

Carolyn, 20" x 15", Arches paper. This girl had unusual proportions, a small head and a bulky body. I exaggerated the proportions a bit, and since I was sitting down and looking up at the figure, the bulk of the body is even more apparent than it is in life. Here I was interested in the shapes of the lower torso. I used the shadow of the arm to explain the interesting protrusion of the right hip. I also used the background to develop the shape of the right lower arm. This shape isn't particularly accurate, but I wanted to get the feeling of the interesting curves of the arm.

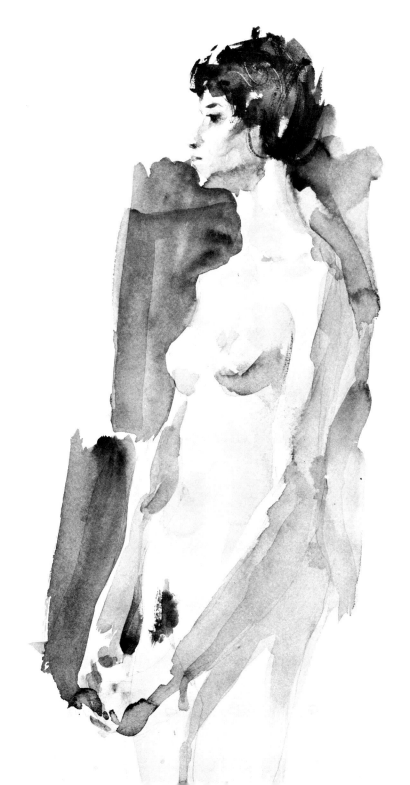

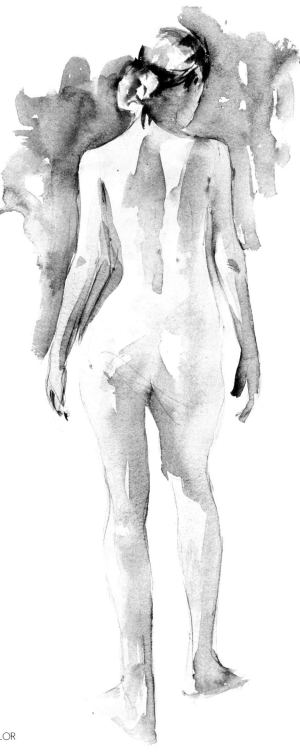

Pink Figure, 20" x 15", Fabriano paper. This model had lovely flesh tones, and I concentrated on them in my sketch. There's a great deal of warmth here, and red certainly dominates in both the lights and the shadow. On the other hand, there are some definite cool areas which make the warm, reddish sections all the more vibrant. There's a transition from warm to cool in the head. The front of the face picks up some cool reflected light. As the shadow goes back toward the neck, the colors become warmer. I painted this whole area at the same time, wet-in-wet. I washed in the light values of the figure first and allowed them to dry. I used white paper to pick up a highlight on the lower torso. In the first wash, I used both warm and cool colors, trying to let the cool colors dominate in the lower torso area. Then I added the shadow shapes, blocking them in quickly and freely. Again, I was more interested in color, so this figure is generalized, but I was careful to delineate the shapes and the gesture. Detail shown at right.

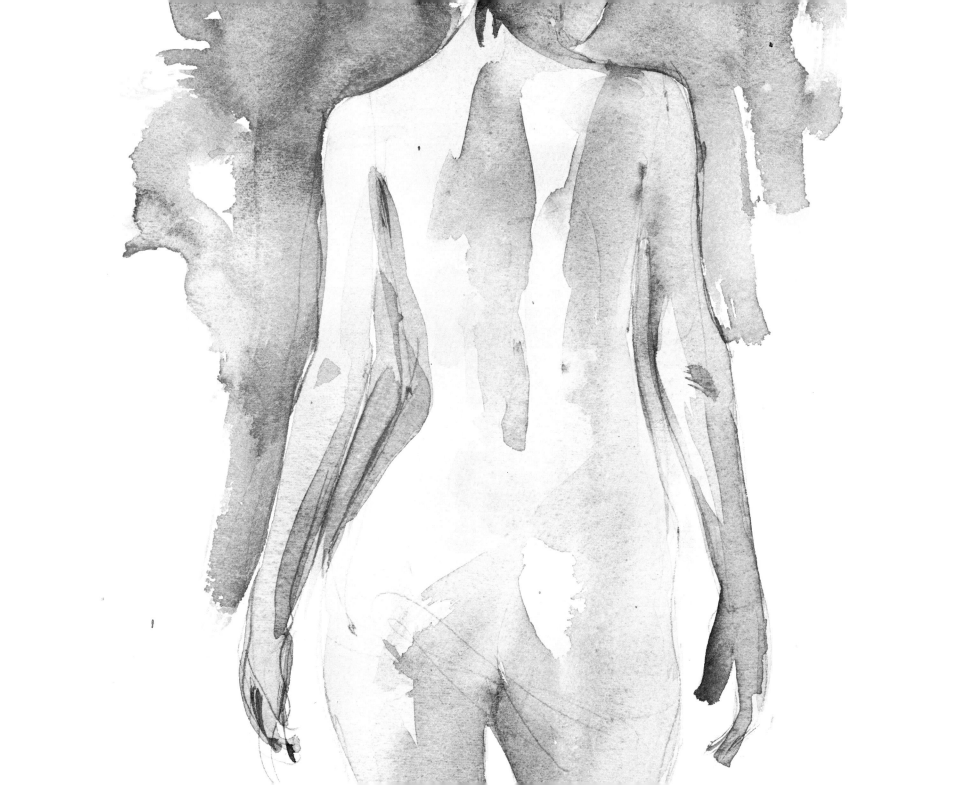

10

FIGURE IN
TWO VALUES

Until now, you've been thinking of the figure as a flat form, using just one value. Now you'll bring in a second value—shadow, which suggests bulk and three-dimensional form. Simple light and shadow are the quickest and easiest ways of showing form. You'll use obvious light and shadow shapes in your exercises; however, there will be many times when shadow won't be obvious, and because of this, the modeling of the figure will be more subtle and, consequently, more difficult. First though, practice with simply lighted figures—with obvious light and shade—until you thoroughly understand the structure of the figure and the handling of watercolor.

Render a simple standing figure and assume that the light is coming from above and left. Start off with a simple silhouette. The materials will be the same as before. I'm sure you're tiring of using only black and gray, but don't despair. You'll be into color soon!

Diffused Lighting Diffused lighting occurs when light shines on an object from several different angles. The object requires a lot of modeling to show its form and bulk.

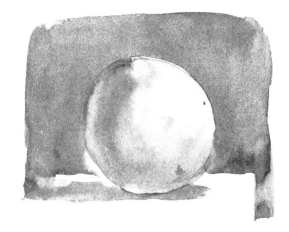

A Single Light Source When only one light source shines on an object, it's much easier to show the object's form with only two values.

Two Value Figure: Step 1 Block in the standing figure illustrated here. Use the same values and procedure that you used in Project 8.

Two Value Figure: Step 2 Mix up a darker value. Don't worry too much about the value of this shadow; just make sure it's obviously darker than the value used in Step 1. Block in a strip running down the left side of the silhouette's head. This strip should cover about half the face. As the strip reaches the base of the neck, take a short, tapering jog over toward the left shoulder. This stroke tapers and gets lost because of the construction of the shoulder. The construction of the figure affects the shapes and sizes of the shadow masses. Start a new stroke at the point of the shoulder. This shadow form will eventually describe the whole side of the torso, including the arm.

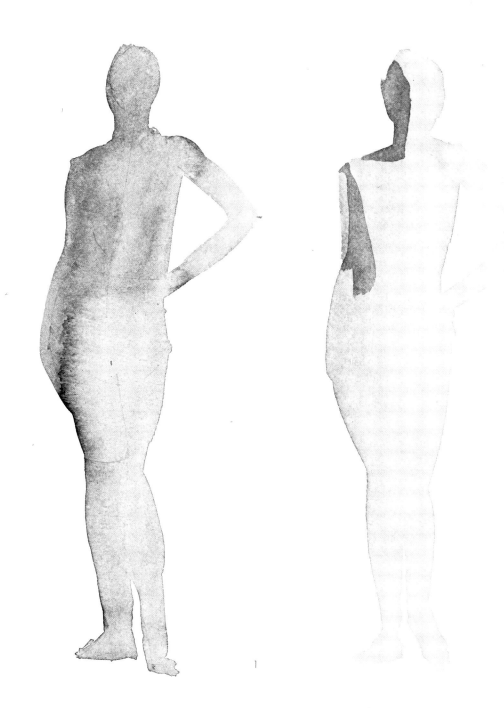

1

2

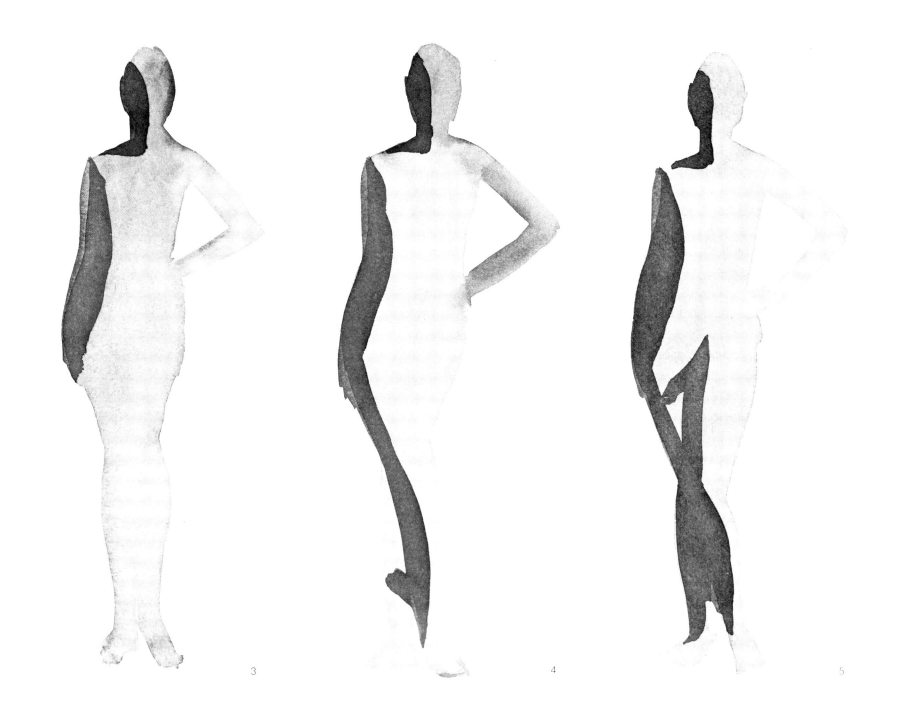

3

4

5

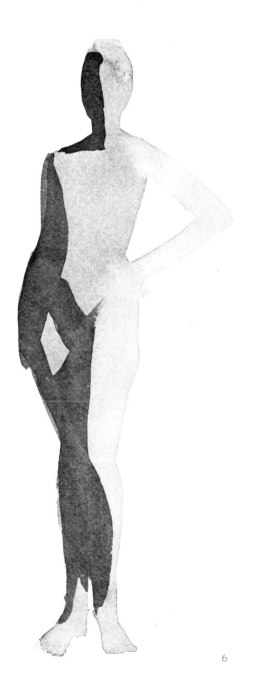

6

7

Two Value Figure: Step 3 Continue the stroke on down the torso. The stroke gets fatter as it progresses down the torso and ends at about the point of the hip. Make this a nice, easy stroke. It's a general stroke and gives only a broad idea of the torso's construction.

Two Value Figure: Step 4 With a new stroke, pick up the shadow you just painted. You'll probably have to recharge your brush, but aside from this, consider the new stroke a continuation of the torso shadow. Make the leg shadow just as simple as possible, but because of the particular construction of the leg, it will be narrower than the torso shadow. The leg shadow starts on the right thigh, makes a diagonal, and picks up what will be the lower left leg. This step uses the concept of relating various parts of the figure, discussed in Project 9. The lower left leg is related to the upper right leg by the shadow.

Two Value Figure: Step 5 Now start blocking in the lower right leg. Finish the shadow describing the lower legs; then make an upward stroke to the crotch.

Two Value Figure: Step 6 Describe the underplane of the stomach. The leg and lower torso shadows are now connected with the upper torso shadow. All the major shadows should form a cohesive pattern. Avoid bits or pieces of shadows that give the figure a disjointed, unconnected look.

Two Value Figure: Step 7 The shadow describing the left breast and the left arm can't be connected with the main shadows; so, rather than stretching the point, block in both shadows by themselves. The breast shadow is a simple, triangular shape, while the upper arm shadow is a thin, straight stroke which continues along the top of the lower arm. Add a small stroke to show where the hand is resting on the hip.

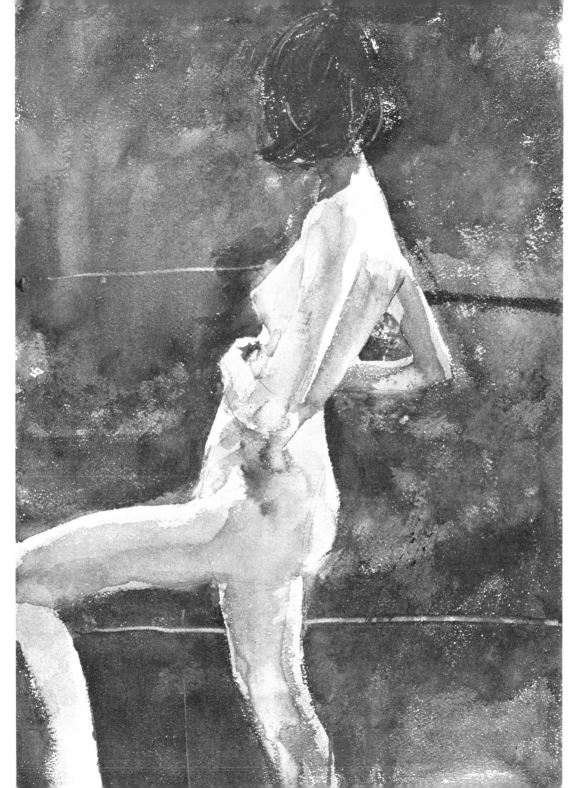

A Gray Day (Left), 22" x 15", Arches paper. I did this painting on a very gray day. The quality of light was important to me. The light was quite definite, but the feeling of grayness was also evident. The skin tones in the first light wash are predominantly cool. I left some white paper showing in certain sections; it's difficult to avoid bits and pieces of white paper when you're painting on a rough-textured paper. My shadow areas are warmer, especially in the arms. Some of the arm color flowed out into the shadows of the hip. I don't worry if areas flood out into adjoining sections; the resulting soft edge can be quite interesting and can add to the spontaneous quality of the watercolor. The breast area was cool.

Gene's Friend (Right), 10½" x 12", Fabriano paper. I did this from a slide projected on my studio wall. I was interested in the sculptural quality of the light on the face, so I carefully delineated the shadow shapes here, using as much warm and cool color as I could. The dark sweater blends with the background. Actually, I painted the two areas—the sweater and the background—at just about the same time. I lifted out the light sections of the sweater with a tissue while the wash was still wet. I also used a tissue to develop some texture in the floor and to soften some of the areas I wanted to fade more. Finally, I added some spatterwork to the textures on the wall and floor.

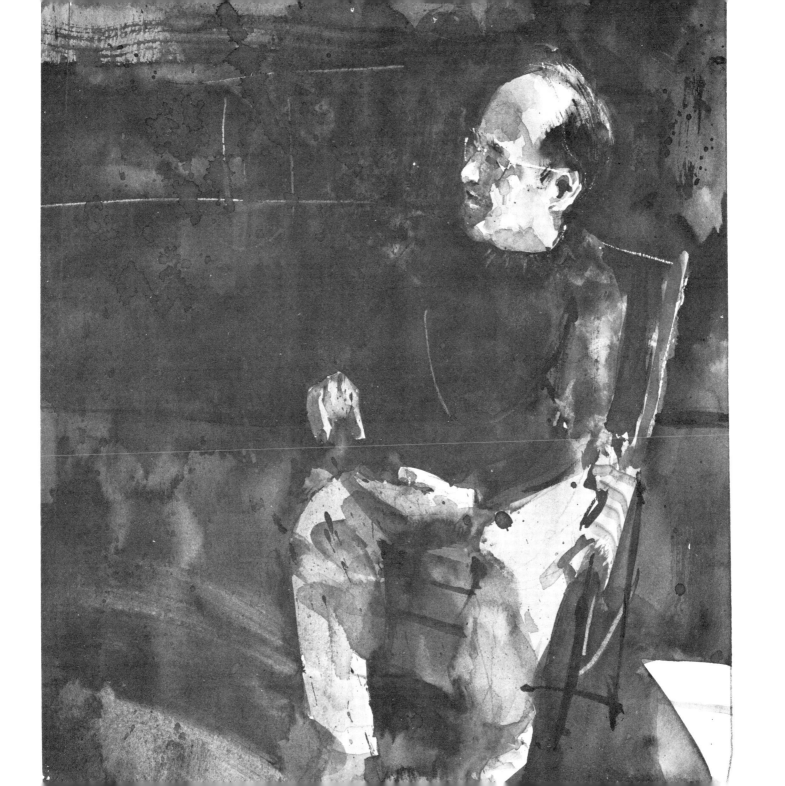

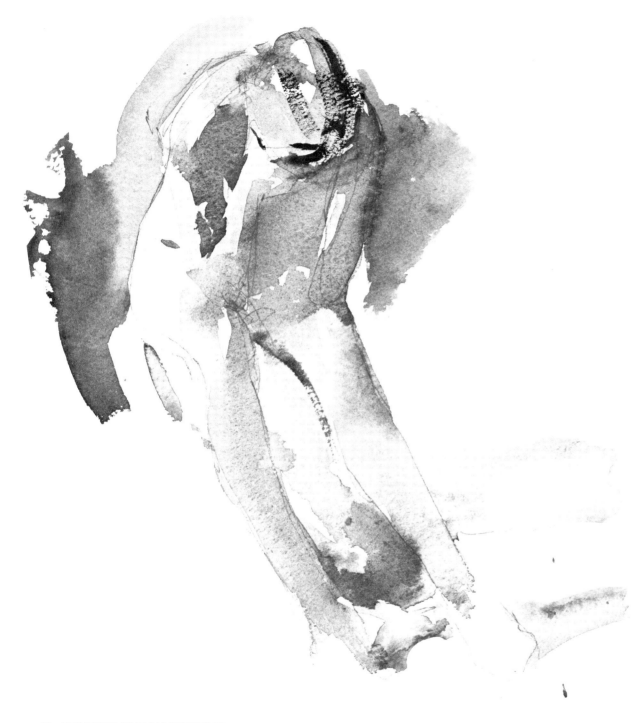

Model Holding Her Head (Left), 8" x 10", Fabriano paper. This is a quick study, using mostly shadow shapes to show what the model is doing. You need a strong single light source to do this. I painted the shadows with just one value, with the only darker accent by the right hand.

Man in Sunlight (Right), 14" x 8", Bristol paper. The pattern of sunlight and shadow on the face makes an interesting painting problem. Painting "light" is something that interests me very much. I picked up specks of light on the glasses with touches of opaque white and some scratching with a razor blade. Texture in the hair is rendered with a brush handle in a still wet wash. I also used dry-brush and some spatterwork to provide textures.

Blue Hat (Far Right), 12" x 6", Bristol paper. I tried to tie in the values of the hat with the cast shadows on the face and hair. The actual values in the hat and cast shadows were darker, but I like the feeling of light and air caused by the higher-keyed darks.

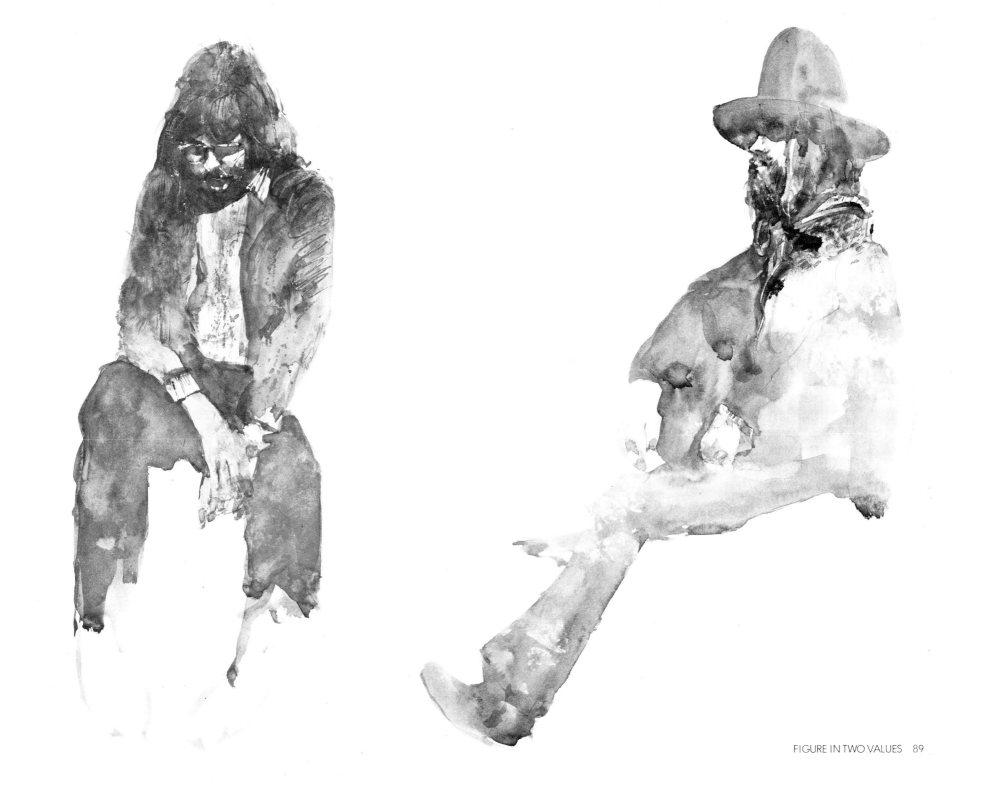

SPECIFIC SHAPES
OF THE FIGURE

In Project 10, you suggested shadow shapes as simply and directly as possible. In this project, you'll use that same technique on more advanced figure work. The main difference will be that you'll concentrate more on accurate shapes. The shadow shapes will be simple, but they'll also be descriptive of the figure's form.

A variety of shapes make up the outside boundary of the figure. Compare the shoulders of the figure used in this project. The left one is formed by a simple curve, while the right one is angular. Now look at the upper arms. The outsides have distinctly curving forms, while the insides are quite straight. In the lower arms, the outsides are curving, while the insides again are straighter. The right side of the upper torso is straighter, while the left side has flowing curves. The lower torso has one flowing curve on the right side, while the left side has several smaller, sharper curves. Constantly be aware of

this variety of shapes. As a general rule, one side of a form will be different in shape from the other side of the form.

The human form is a combination of curving and straight lines. Angles work against curves, and curves work against straight lines. Seeing shapes accurately and being able to put them down accurately in terms of size and shape are important to figure painting.

Few things are symmetrical in nature, and it can be safely said that nothing repeats itself in the human form; so variety and contrast are key points. Don't assume that all human figures should be painted the same way. Each one is different, and each one has unique shapes. Always begin by studying and observing. Make sure you understand what's happening in the figure you wish to paint before putting pencil or brush to paper. Your main job is to describe the particular form of a particular figure.

Project 10 used simple shadow shapes to show the overall bulk of the figure. Now you'll carry this one step further and show not only bulk, but also a form and construction that describes a particular muscle and bone structure. These shapes are based on the anatomy of the figure. The bone and muscle structure causes the contours. I suggest studying one of the good anatomy books to understand the structure of the body. However, you can do a passable figure without a thorough knowledge of anatomy. Simplicity is the key. Concentrate on the major planes that describe the bulk, form, and major construction of the figure, rather than putting in small, unimportant forms.

Naturally, you won't always have good shadow shapes, but they're a big help in the beginning, and they're a good way to suggest the contours of the body without subtle and complicated washes. They also show the relationship of the various forms to one another.

Now let's get on to the steps. Your materials will be the same as usual.

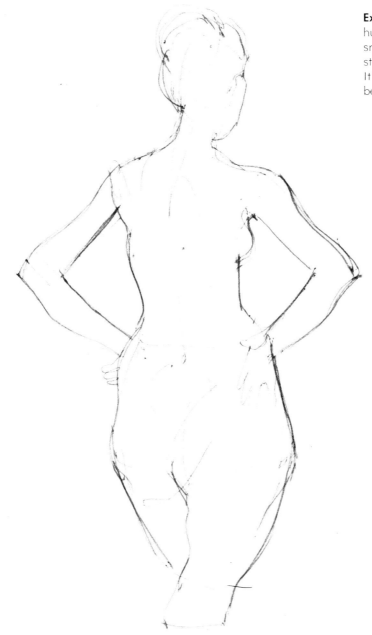

External Shapes of the Figure. The exterior of the human form is composed of various shapes, some smoothly rounded, some quite angular. There are straight lines and curves, both gentle and sharp. It's important to analyze these shapes carefully before attempting to render the figure.

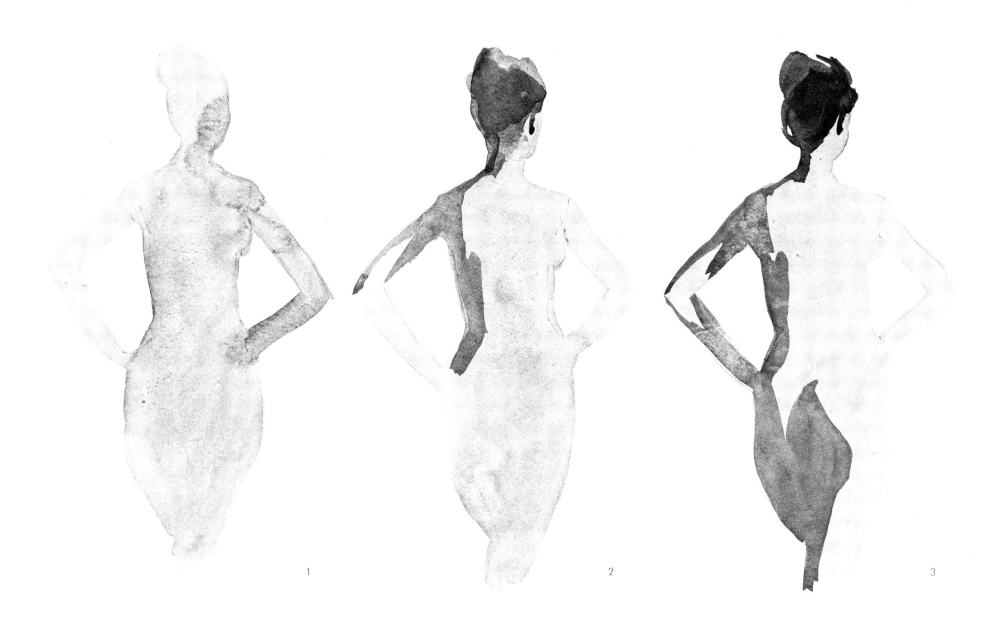

1

2

3

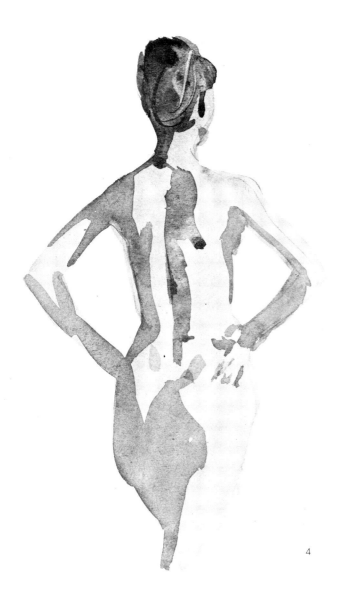

4

Specific Shapes: Step 1 Make a simple silhouette and allow it to dry. It's perfectly okay and good practice to work directly with your brush without pencil guides. On the other hand, pencil work is all right, but *don't* make hard, precise outlines, and simply fill them in. Sketch just the torso and upper legs to stress the involved construction of the back.

Specific Shapes: Step 2 Mix up a shadow value. Start with the hair; then narrow the stroke to describe the neck. The stroke changes direction at the base of the neck. As it follows the line of the shoulder, it slowly gets fatter until it reaches the side plane of the shoulder blade. Block in this plane and the shadow of the left arm and its cast shadow. Continue the stroke to the bottom of the shoulder blade, where the wash goes further out to show the rounded form of the ribcage.

Specific Shapes: Step 3 The wash now reaches the side plane of the lower torso. The inside shape here is quite straight, contrasting with the curving forms indicating the lower back. Block in the whole shadow plane with a single shadow. A big shadow shape like this is very descriptive. One value does what it would take many small, subtle value changes to accomplish. The use of one value works as long as the shadows are right in size and shape! This shadow shape makes a subtle curve over the backside and takes a straight jog down the leg.

Specific Shapes: Step 4 Make the side plane of the right shoulder blade quite thick, as opposed to the much thinner plane running down the backbone. The brushstroke should emphasize the straightness of these planes and their slightly angular quality. You're showing the boney, much sharper form of the back in contrast to the more rounded forms of the lower torso. The shadow cast by the upper arm follows the rounded form of the ribcage and disappears as it approaches the hip. Make a large, simple shadow on the lower arm. This big shadow shape shows that the arm is pulled back, causing the lower arm to be away from the direct path of light. If this arm had been in the light, you would have known that the elbow was pulled forward.

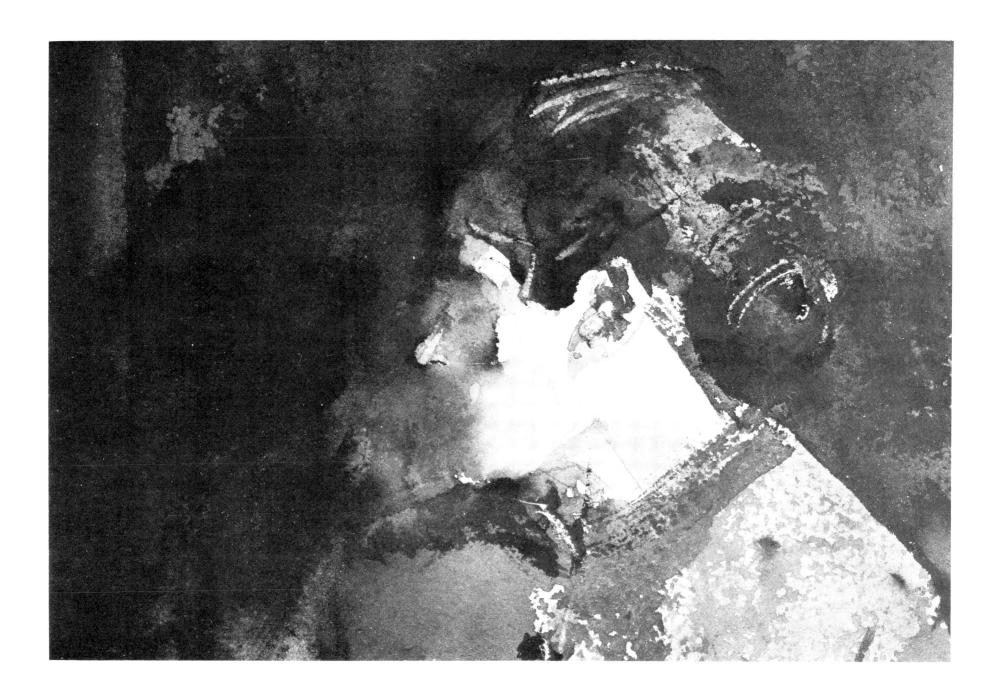

Model, 19" x 8", Arches paper. I did this painting from a photograph probably taken by Toulouse-Lautrec. I was interested in how the front of the face gets lost in the background, so I used soft edges here, with hardly any definition, just a small hard edge at the end of the nose. I scratched lights into the hair with my fingernail. The picture is predominantly dark, with three light accents—the two hands and the face. I washed in the lights and then added the darker values. On the buttons, I lifted out some of the lights with a razor blade. Detail shown at left.

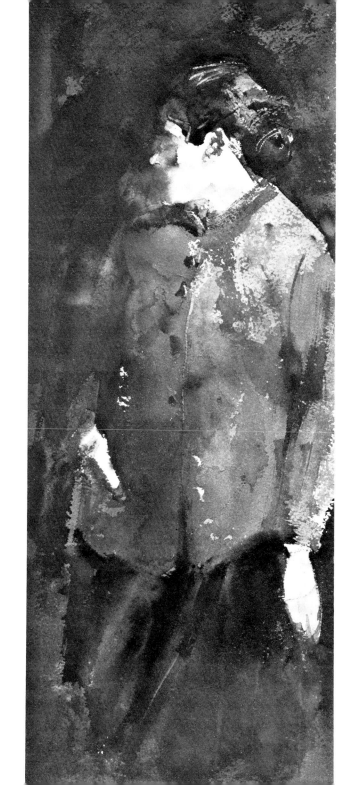

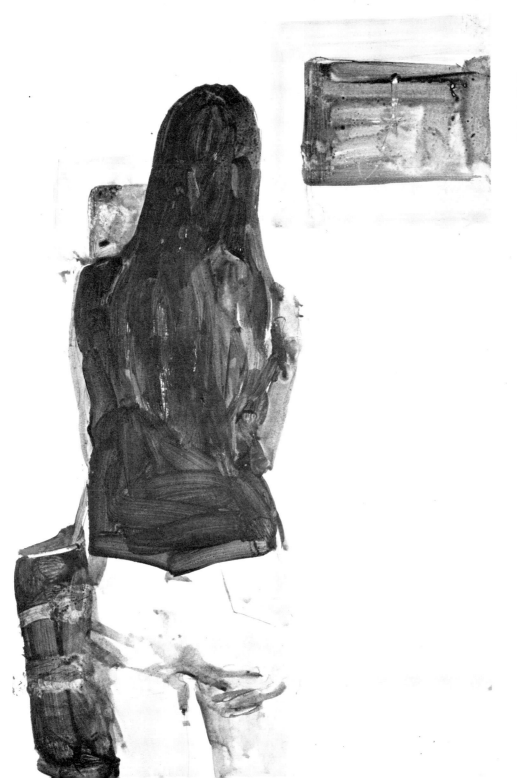

Standing Girl, 20" x 16", Bristol paper. This was from a photograph in a magazine. The girl has taken a subtle but graceful pose. A stance like this can be very attractive, more attractive than a much more dramatic pose might be.

Hot Pants, 16" x 20", Bristol paper. As in many of my figure paintings I like off-beat, awkward poses. The very "leggy" qualities interested me and I exaggerated them by making the lower legs and boots longer than they actually were.

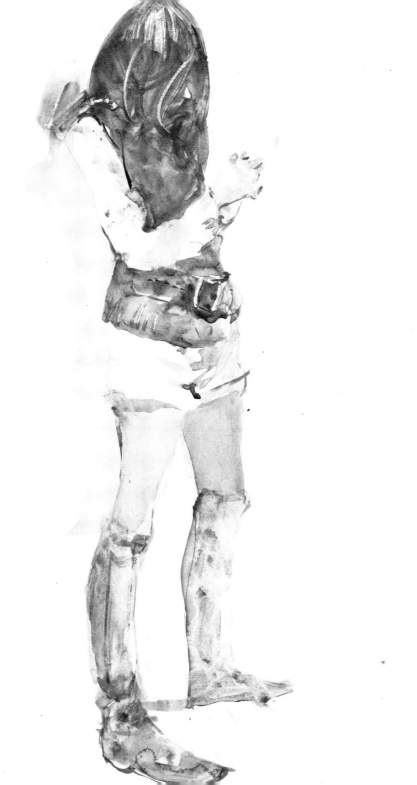

12

FIGURE IN THREE VALUES

Now you'll take the two value figure one step further and create a middle value between light and shade. Assume that the figure is lighted with the same single light. This will still be a simplified figure. Actually, there are more than three values in a figure, but you couldn't and shouldn't put in every small value change that you see in the figure. Someone once said that it's what you leave out, rather than what you put in, that's important. This is a good rule of thumb, especially with watercolor.

You'll establish the middle value from the shadow. Instead of mixing a middle value on the palette, a damp brush will allow the shadow value to run out into the light to create a third tone, and at the same time, the brush acts like a sponge and softens the edge between light and shadow. Although this is a "simple" approach, it's only simple if you have good control of the amount of moisture in your brush. The shadow value must not be too wet or too dry. If the brush is too wet, the water from the brush will dominate the shadow color, and instead of the shadow coming out into the light, the water in the brush will attack the shadow value and create a balloon in the shadow. The shadow must be dominant, and the brush is only giving it a chance to move out of its boundaries into the light. Paint consis-

tency is important here. The technique of the graded wash, introduced in Project 4, is important too, since you're only making blends in selected sections of the shadow boundary.

Each step illustrated in this book must be a separate sketch, so there are variations of value and shapes among the sketches. Each figure you'll do will also be a little different, so don't worry if the middle value flows out too far on one attempt or not quite far enough on another—or if the shapes you draw aren't exactly perfect. On the other hand, I want you to be as accurate as possible, without sacrificing the freedom of brushwork you've worked on in preceding projects. Again you'll use Payne's gray or ivory black and all the other materials you've been using right along.

Until now, I've worked directly with a brush, without pencil guide lines, in order to develop a feeling of freedom and spontaneity, but in this case I've sketched in the figure first with pencil. I did this for the sake of accuracy; but if you do this, remember not to just fill in outlines. From now on in the demonstrations, I'll be using pencil work first, but never think of pencil lines as hard and fast boundaries. The pencil work is meant only as a guide and suggestion for the brush.

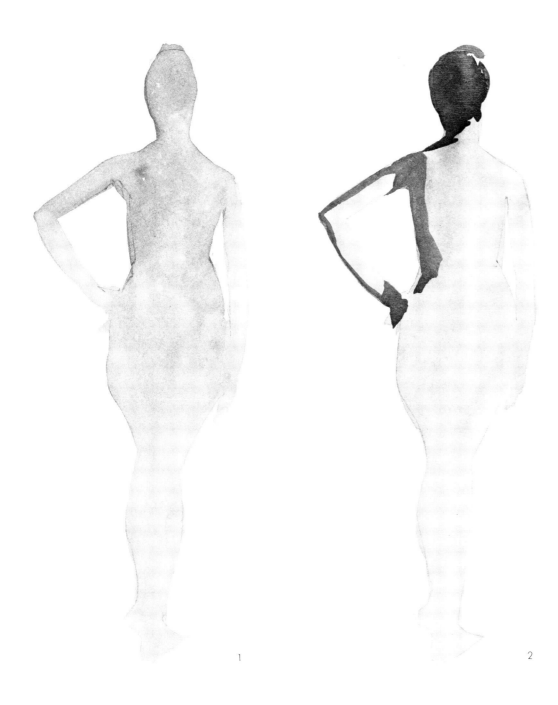

1

2

Middle Values: Step 1 Make a simple silhouette. Allow this first wash to dry.

Middle Values: Step 2 Then, with a considerably darker value, block in the shadow shapes, beginning with the hair. Remember that the amount of bleed (or blend) you'll get in the next step depends on how wet a brush you use and how wet the shadow is. Don't paint all the shadows. If you paint in all the shadow shapes right down to the feet now, the shadows in the shoulder and upper back might become too dry for blending.

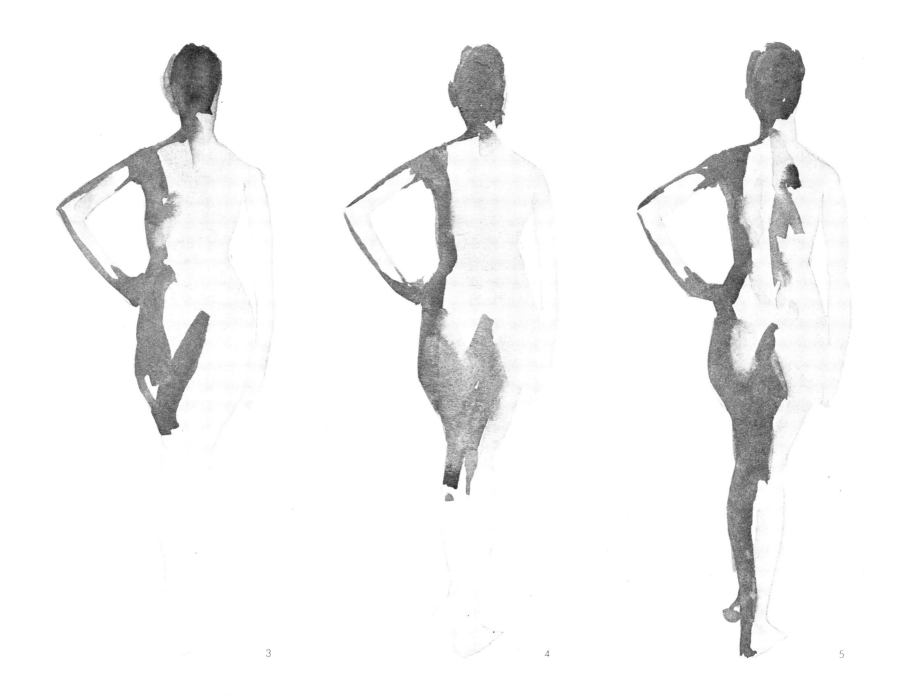

3

4

5

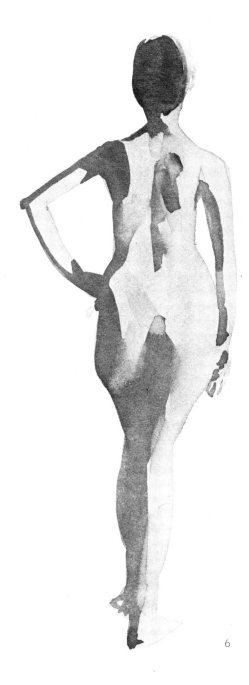

6

Middle Values: Step 3 After doing only about half of the shadows, go back and do the blends. Rinse your brush and give it a good shake. Soften the neck shadow first by running the damp brush along the shadow boundary, allowing some shadow value to bleed out into the upper middle of the back. Don't overwork this; make just one or two passes with your brush. If the bleed is going out too far, blot the brush lightly with a tissue after each stroke. Since your damp brush acts like a sponge, you can control the amount of bleed using only the brush. If you blot the brush with a tissue after each stroke, the brush stays damp, rather than becoming actually wet. Soften the shadows in the middle of the back. The shoulder blade is often a sharp, boney form, so leave it untouched. The back is less definite, so make a softer edge here. Finally, begin to fill in the shadows of the lower torso.

Middle Values: Step 4 Soften the shadows on the rounded forms of the buttocks to contrast with the harder edge in the upper section of the lower torso. Sometimes, hard edges, like the one on the hip near the hand, are left purely for the sake of making them a different shape from the adjoining soft edge, and vice versa. When all edges are soft, the figure looks mushy and formless; all hard edges make the figure look like a cutout. You want a combination of hard, precise edges and soft, some-times "lost" edges.

Middle Values: Step 5 Add the rest of the leg shadows along with some shadows to describe the middle of the back. Blend the leg shadows. Notice that by the time this was all done, the leg shadows were almost dry and didn't blend too well.

Middle Values: Step 6 Block in the right arm. This time, don't blend any edges, but *blot* the lower arm shadow to lighten it and give the appearance of a soft edge. Shadows can be blotted to lighten those that have become too dark or just for the sake of a subtle value change within the shadow. Here, blotting gives a suggestion of softness.

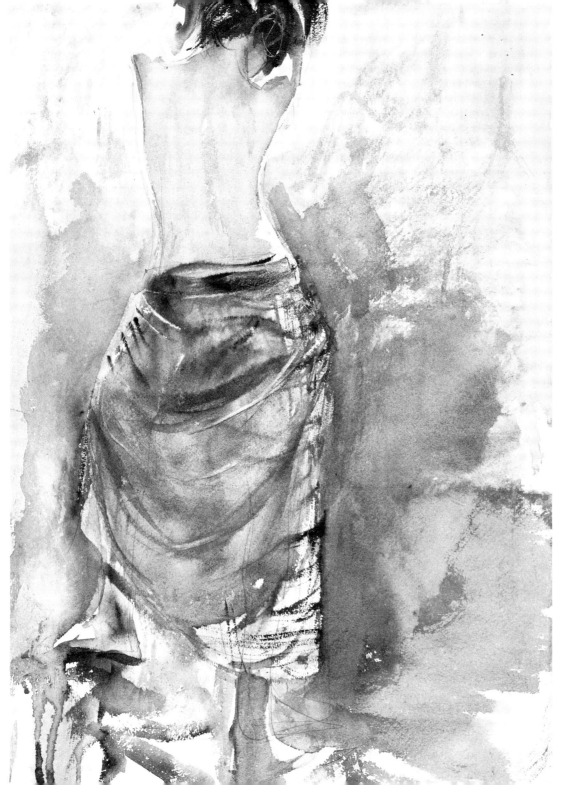

Draped Model (Left), 19" x 13", Fabriano paper. I was especially struck by the back, which is mainly in shadow, and its luminosity in comparison to the dark robe which the model had wrapped around her. It's important to keep shadows luminous, and in this case I exaggerated the lightness of the back in shadow. I didn't darken the background adjacent to the upper part of the figure. It's not always necessary to make a light section of the body stand out by using dark adjoining values. In this case I've just a few contrasting areas, such as the light-struck section on the right hip where I did use a dark value to set it off. I used warm color in the arms and shoulder areas. I didn't want to get involved with a lot of folds, so I generalized the robe and left just an indication of light in the lower right-hand section. I scratched in some fold indications, but in general, I tried to keep the robe as simple as possible. Notice the soft edges between the robe and the surrounding areas.

Mary II (Right), 15" x 20", Fabriano paper. This sketch was done on the same night as *Mary I* (p. 60) and with the same model. I merely took two different points of view. I always have a desire to add background but I feel that figure studies are often better by themselves. Here it seems to me that this study is quite successful with just the subject and no background. The simple, dark mass of the hair and the delicate values in the flesh tones work well by themselves.

13

FIGURE IN
FOUR VALUES

Happily, we're into the last project using just grays. This project is to render a full value figure containing good drawing, good shapes, and a good value range that completely explains the form of the figure.

It's not really possible to pin-point four exact values in watercolor. There will always be some variation since mixtures of water and pigment can't be repeated exactly each time. The important point is keep the two, three, or four values in proper relationship to one another. The middle values must never be as light as your light area nor as dark as your shadow. No value within a shadow area should be as light as a value out in the light. Conversely, no value in the light should be as dark as an area in shadow. In other words, you must keep your lights looking like lights, keep your middle lights looking like middle lights, and your shadows looking like shadows.

Four Value Figure: Step 1 The first steps in this project will be just the same as in Project 12. Wash in the silhouette over carefully drawn boundaries. Use Payne's gray or ivory black.

Four Value Figure: Step 2 Now come the shadows. Starting with the hair, block in the darks carefully. The ear is light-struck, so paint around it. Work around the chin line and on to the upper arm, shoulder, and arms. To show the soft underplane of the shoulder, allow some of the shadow to flow out into the light by using a clean, damp brush to make a blend. Leave the rest of the edges in the arm hard to show the difference between the harder forms and the much softer feeling in the shoulder muscle. It's now very important to articulate the fairly complicated forms in the upper torso. Here again, the differences in edges suggest the qualities of the forms. Contrast the rounded front of the breast with the much harder form on the underside of the breast.

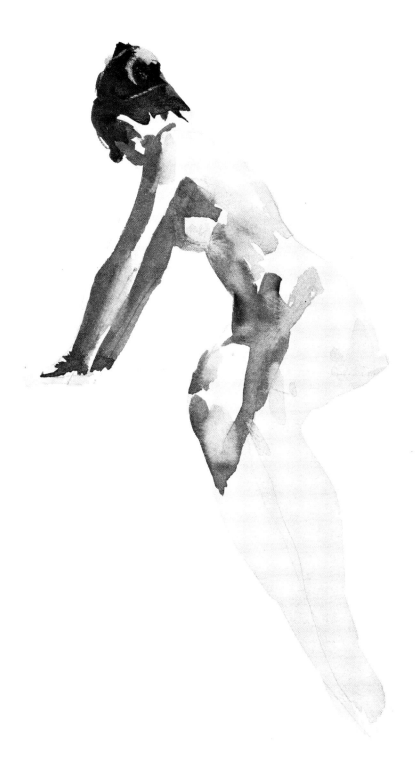

Four Value Figure: Step 3 Go back and block in the hair with deeper color. This will be one of the darkest parts of the figure and noticeably darker than the skin tones in shadow. The dark accent of the hair gives the shadows luminosity. Continue with the work on the torso. To indicate the form of the ribcage, add a light middle value. These middle lights separate the lighter areas of the shoulder and hip. This is a good example of value changes explaining the construction of the body. The upper back forms a top plane; then the plane changes as it passes down the back and becomes an underplane. Since the hip protrudes, keep your values light once again to show this protruding top plane. Carefully indicate the large front plane of the stomach and continue the shadow wash down the legs. Note the shadow separating the upper legs. The left side of the shadow is straight and hard. As a rule, cast shadows are hard-edged.

Four Value Figure: Step 4 Soften the shadow on the right knee. The round form contrasts with the harder cast shadow on the upper right leg. This is another example of edges showing the character of each form. Finish up the lower legs with a large, single wash to generalize the shadows into simple masses. Now add a few more dark accents to give the figure its full value range. Add no more than three or four accents to separate the left arm from the right arm. This right arm is behind the breast. To show this, add a dash of very dark value where the right arm stops and the breast begins. *Don't* paint the whole right arm with this darker value. Add another dark to the right wrist area. This indicates the lack of any reflected light between these two wrists, which are held tightly together. In contrast, the mid-section of the arm looks lighter and has the feeling of reflected light and luminosity. There's no reflected light under the breast, so add another darker accent. To separate the shadows describing the lower legs from the adjoining cast shadow on the couch while preserving a feeling of "lost edges," add just one small dark. In the same vein, separate the knees by adding another dark where the left knee hits the underside of the right upper leg. At first add these darker accents when the shadows are dry. When you become more adept, you'll add these darker accents wet-in-wet, since all edges in shadows should be soft.

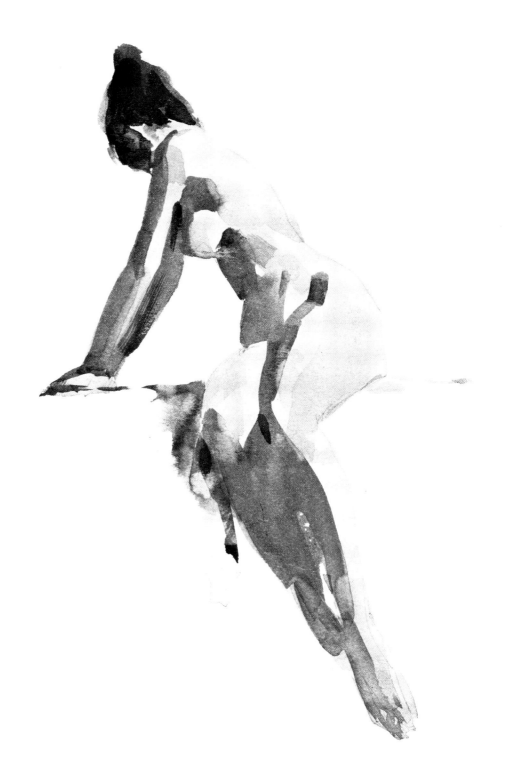

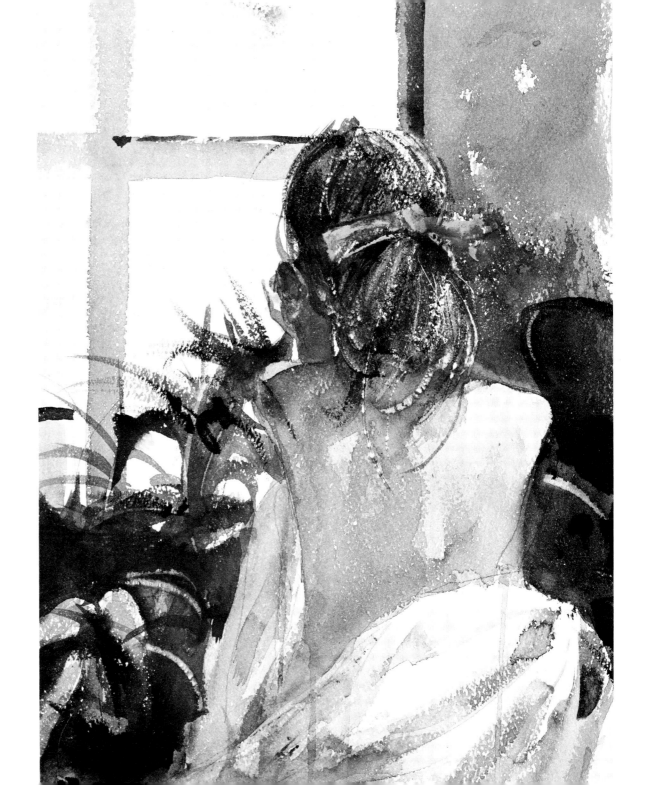

Back Study, 13" x 9", Arches paper. As in many of my pictures, I'm interested in the effect of light, and in this painting I wanted to get the quality of the light glancing across the model's back. The values are simple with warm colors predominating over the shadow. I used cool, light-struck areas as contrast in the warmer tones. The room was busy with lots of plants and objects, but I tried to generalize these into a fairly dark and simple background area. Painting a cluttered room is a question of selection, and it's necessary to generalize and lump things together into areas of similar value. Actually, to paint the background I just used grays—mixtures of Hooker's green and cadmium red, plus some blues and raw umber. Then I began to pick out a few of the more important details. I scraped out some line indications in the plants and furniture with my fingernails while the wash was still wet, and then I added some of the important darks with pure pigment.

14

CHOOSING COLORS

Applying color depends on a good understanding of wet-in-wet, an overall understanding of what happens when you mix paint and water and put this combination on wet or dry paper, and understanding the importance of good paint consistency.

The colors you'll use for figure painting will depend on three considerations. First, you'll use colors that mix well for flesh tones. Next, you'll use colors that fit the particular complexion you must paint. And finally, you'll use colors that appeal to your individual color sense. There's no single formula for flesh tones. The combinations I suggest should be considered only as suggestions. Start with them, but then try other combinations until you find the range of colors that suits you and your impression of the model's complexion.

Basically, you'll need a red, a yellow, and a complementary color—either blue or green or both. Of the reds, I find cadmium red light vermilion the easiest to handle and the most useful. Alizarin

crimson can be useful in dark areas, but I don't often use it because it's a very strong color and can be quite difficult to mix. It likes to dominate other colors in the mixture. I generally use alizarin crimson only with a dark blue like ultramarine or phthalocyanine blue (phthalo blue) to make a rich dark. Cadmium red medium and cadmium red deep tend to be heavy, so I rarely use them for flesh tones.

In yellows, I prefer cadmium yellow light or lemon yellow. Sometimes, lemon yellow can be tacky and stiff, so I usually stick to the cadmium yellow light. I seldom use cadmium yellow medium since it's a bit warmer and stronger and, for me, harder to use successfully. Yellow ochre is a nice, subtle—rather weak—yellow which mixes nicely with red. I often use yellow ochre in my lighter mixtures and raw sienna, which is really only a darker version of ochre, in my darker areas. Cadmium orange isn't a necessary color

for flesh tones, but just a touch can be added to warm up very light, washed-out areas. These colors are my basic warm colors.

For cooling and cutting the intensity of a warm hue, cerulean blue, ultramarine blue, and Hooker's green are all useful. Cerulean is a weak, light blue which doesn't assert itself. For my darker areas, I often go to the green, simply because it comes out of the tube at a darker value than the cerulean blue. The cerulean blue can be used nicely in darker areas, and Hooker's green in lighter parts. It really depends on the particular complexion at hand. Ultramarine is a bit harder to use than the other two because it's a stronger color. It's good in dark complexions, but stay with cerulean or Hooker's until you get your feet wet. Phthalo blue is also a fine, dark blue, and I like it better than ultramarine blue. Its only drawback is its great strength—it tends to dominate mixtures. It's even stronger than ultra-

marine. However, phthalo blue mixes well and it's excellent for rich darks.

In watercolor, raw umber isn't as dark as burnt umber. Actually, it's something like a darker raw sienna, and you might like to try it instead of raw sienna in darker areas. Burnt umber and burnt sienna can be useful in very dark accent areas, but I probably wouldn't use them in other flesh areas. Black is a beautiful color, but don't use it in flesh tones. If you're clever enough to use black successfully in flesh tones, you don't need this book.

These are the colors I suggest for flesh tones, but they make a good general palette for any painting problem. For hair, clothing, and surrounding colors, burnt umber and black would be necessary additions. Again, these choices are my own. Almost every watercolorist will have his particular favorites. Try these, but eventually you'll find other colors which appeal specifically to you.

15

FLESH TONES

I'll start our discussion of color mixing with flesh tones. Unless you wish to specialize in nudes, you'll probably paint more clothed figures than nudes, but students seem most interested in mixing flesh tones, so let's deal with this area first.

Complexions are just mixtures; there's no secret or formula. As I've said, everyone's skin is different. Complexions run from rich dark in a black person to the high-keyed, delicate lights in a redhead. Part of the fun of painting nudes is seeing and mixing the exciting warm and cool variations that make up complexions—so, don't look for formulas or short-cuts.

In this project, you'll start with light values for light-complexioned figures. Later you'll mix shadows and the lighter values for darker complexions. The problem in mixing flesh tones in watercolor is arriving at the subtle combination that makes a good complexion color while using strong colors like red and yellow.

Just to make the job a bit easier, use yellow ochre instead of cadmium yellow lemon for this first exercise. Cadmium yellow lemon makes a fresher, clearer wash when mixed with red, but because the cadmium yellow is strong, you might have some trouble controlling it. For the blue, start with cerulean. It, too, is a fairly weak color, compared to the ultramarine and phthalo blues. Eventually, you'll try all of the colors mentioned in Project 14, but for this exercise in color mixing, limit yourselves to cadmium red light, yellow ochre, cerulean blue, cadmium yellow lemon, and cadmium orange. In the last step, you'll substitute cadmium yellow lemon for yellow ochre, and you'll experiment with cadmium orange. The materials are these: number 8 watercolor brush, a half sheet (15" x 22") of good quality watercolor paper, pushpins, clean water, and the five colors—cadmium red light, yellow ochre, cerulean blue, cadmium yellow lemon, and cadmium orange.

Flesh Tones: Step 1 Put on your palette a fresh squeeze of cadmium red and yellow ochre. Dip your brush into the water, give it a shake, and dip it into the red. Make a swatch about an inch square. Quickly dip your brush into the yellow ochre, and make another swatch about an inch from the red swatch. Immediately draw your brush with the ochre over and across the lower section of the still wet red swatch. Both colors should be wet enough to flood together. Now clean your brush and give it a hard shake. Continue where you left off, making several zigzag strokes back and forth, down and away from the swatches. Carry this mixture down a couple of inches. If you find the mixture is getting too yellow or too red, work more of the weaker color swatch out into the mixture. If the brush is too wet, the mixture will be too light and washed out. If the brush is extremely dry, the mixture will be too heavy and dark. The mixture should be an average between the red and yellow. The subject's complexion will dictate whether you choose this average or go toward the yellow or red side.

Flesh Tones: Step 2 Now repeat the same procedure, but this time you'll add blue. Go through the steps of mixing red and ochre and making zigzag strokes, just as you did for Step 1. Go back to the palette quickly while this mixture is still wet. Pick up some cerulean blue with your brush, and make a swatch about an inch below and to the right of the ochre. (If you're left-handed, perhaps it would be easier to add the blue below and to the left of the red; it doesn't make any difference which side you work your blue from.) Clean your brush in the water and shake it quickly. Take a diluted version of the blue right into the center of the red-ochre mixture. Don't brush the blue around. Let the paper, paint, and water do all the work. You should have a gradation from warm to cool. If the blue isn't diluted enough, it will dominate too much, but diluted blue doesn't mean a soaking wet brush. Always shake your brush before doing any wet-in-wet work.

Flesh Tones: Step 3 Repeat the same procedure substituting cadmium yellow lemon for yellow ochre and cadmium orange for the blue. The yellow will have to be diluted a little with water to cut its strength. Cadmium yellow is harder to work with, but once you get used to diluting it properly, all will be well. Cadmium orange can pep up a dull, washed-out, light area. However, this is a strong color too, so use very little and make sure your mixture wash is good and wet so that the orange can be absorbed. Don't work the mixture with your brush. Wait for it to dry to see the result.

16

WARM AND COOL WASHES

You've tried color mixing with swatches; now you'll try the same thing in a figure. This first step will be a simple color silhouette with no light and shade. (It will remain the first step when you're doing a full value figure later.) This step establishes the color identity of the particular figure you're going to paint. It's important to make a strong color statement here, since it will set the tone and the foundation of what you're going to do, in terms of color, in a particular figure.

Be strong with color. Watercolor washes always dry lighter and duller, so a color that looks wild when wet will often look tame when dry. Understandably, students are more cautious and tentative than they should be when working with watercolor. The fear of making mistakes causes many mediocre pictures. Make definite statements; don't make timid, fearful strokes. A definite, strong color statement, even if it's wrong, will teach you something about color. If you constantly use washed-out, indefinite colors, your figures might be passable, but they'll probably be dull and uninteresting. If you think you've gone overboard and your color appears too wild, don't try to correct it with your brush. You can blot the wet wash with a tissue; but beyond this, don't fiddle with it! Always view questionable areas as part of the whole picture. Something that looks bad by itself might look fine

when seen as part of the whole painting.

Let's assume that this figure has a light complexion. Colors for the basic wash will be cadmium red light, yellow ochre, cadmium yellow lemon, and cerulean blue. There are other colors that could be used, but don't try them yet.

Although you'll often mix colors on the palette, you'll also add pure color directly to the paper. For example, when you want to add blue wet-in-wet add the blue directly and don't mix it on the palette with the warmer tones. You'll see what I mean as you go along. Just one reminder —when working wet-in-wet, it's important to let the paper, paint, and water do the mixing. Don't try to work the second color in with the brush. You'll only disturb the wash. The job of the brush ends when it delivers the color to the proper area.

For this project, you'll need a number 8 watercolor brush that "points" well! A tired brush makes everything harder. You'll need water; a palette set with cadmium red light, yellow ochre, cadmium yellow lemon, and cerulean blue; good quality paper; pushpins; your drawing board; and a box of cleansing tissue.

As you'll notice, my sketches are freely brushed in. I want you to concentrate on color here, so don't worry about careful boundaries. Work broadly as you did on the first gray silhouettes. This is a good time to use spontaneous brushwork!

Warm and Cool Washes: Step 1 After pinning the paper to your drawing board and squeezing out fresh paint on your palette, mix a puddle of either cadmium yellow lemon or yellow ochre and cadmium red light. (Try both the ochre and cadmium yellow to see which appeals to you.) Satisfy yourself that the mixture isn't too red or too yellow. However, go more toward the red than toward the yellow. Block in the head first and then the neck and arms. Take the warm tones down to some place in the upper back.

Warm and Cool Washes: Step 2 Quickly go back to the water supply for a rinse. Give the brush a good shake and pick up some cerulean blue. Mix this with the warm tones used in Step 1. You want an obviously cool mixture here so use mostly cerulean and only a small amount of the warmer mixture. There should be enough water on the brush to make the proper consistency, so try not to add any more water. All this has to be done quickly so that the cooler color gets back to the paper while the warm tones are still wet. Add the cool mixture to the lower section of the warm tones and work downwards, indicating the rest of the lower torso. Again, the warm top wash must still be wet or you won't get a good blend. If it's too dry, you'll have a warm top and a blue middle with a hard line between them!

Warm and Cool Washes: Step 3 Quickly go back to the warm mixture on the palette. Give your brush a good shake, and add the warm color to the bottom of the cool mixture. Working down, indicate one of the legs, then the other. If the figure isn't too big, do both legs with the same brushful. The transition between warm and cool might seem too drastic, but let it dry. The more practice you have, the more subtle the transitions you'll be able to make.

1 2 3

17

LIGHT AND SHADOW IN COLOR

Now you'll combine light values with darker values. The shadows should be simple and rich in color.

This project follows the procedure outlined in Project 10 where you painted a two value figure using grays. Now you'll do the same thing, but this time concentrate on color. Your colors will be cadmium red light, cadmium yellow lemon, yellow ochre, raw sienna, cerulean blue, Hooker's green, and ultramarine blue. These colors are for a figure with a light complexion.

(For a darker complexion you'd use the same procedure, but the shadows would be even darker. The colors would be cadmium red and Hooker's green or ultramarine, with just a bit of raw sienna. Red should dominate in the upper and lower sections of the figure. The torso areas should have the green or blue dominating. The shadow colors should be warm in the head, shoulders, and arms; cooler in the torso; and warm again in the legs.)

Your other materials will be the same as always—a number 8 watercolor brush, good paper, pushpins, water, and drawing board.

1

Light and Shadow in Color: Step 1 Using a warm combination of cadmium red and yellow ochre or cadmium yellow lemon, brush in the figure freely, starting with the head, shoulders, and arms.

Light and Shadow in Color: Step 2 Add cerulean blue across the upper part of the chest while the warm wash is still wet. Allow the blue to blend with the warm tones. Draw the wash down the torso to the beginning of the upper legs.

Light and Shadow in Color: Step 3 Going back to the water jar, rinse and shake your brush. Load it with the warmer color, and quickly return to the figure. Block in the legs. The figure should be very free in terms of boundaries. Don't worry about drawing here, just color. Let this first wash dry.

Light and Shadow in Color: Step 4 Mix up the darker values on your palette, using cadmium red light, raw sienna, and a touch of cerulean blue or Hooker's green. Block in the shadow of the head with the red definitely dominating; draw the color down into the neck, jogging over to the shoulder, and indicating the upper chest and arm areas which are to be in shadow. If you find that the raw sienna is taking over, dip directly into the red on the palette, and add it "straight" into your shadow wash. Be brave! It will dry and won't look quite so strong.

2 3 4

Light and Shadow in Color: Step 5 Back to your water jar and rinse your brush, giving it a shake. Go heavy on the blue or green. Use strong color, but make sure you don't have too much pigment. Good paint consistency means a happy medium between lots of pigment and just enough water to make it flow well. Starting well up in the shoulder area, block in the cooler torso area shadow. Notice how freely these shadows are indicated. Now's the time to enjoy yourself and revel in color without worrying about careful drawing and construction. Brush in these cool shadow areas freely, down to the upper leg area.

Light and Shadow in Color: Step 6 Back to the rich, warm color. With a full brush, start at one of the knees and brush the warm color up and into the cooler wash. (You *could* start from the cool middle section of the figure and work down the legs with the warm colors. It isn't important which procedure you take. I'd suggest you try both.) You should have enough color in your brush to finish off both leg shadows. Cover the left lower leg completely with shadow color. This makes the knee look bent, an example of shadows helping to explain the positions of the forms.

5

6

18

FULL FIGURE IN COLOR

Now you'll do a figure study in color, using three values. I'd like you to concentrate on good drawing and descriptive, interesting shapes. You'll be combining what you've learned about color with your earlier work on values and figure construction. Try to combine free, spontaneous brushwork with an awareness of shapes; but of the two, the spontaneous brushwork is more important.

It's natural to be careful and cautious, and most students never get the feeling of watercolor because they're so afraid of mistakes. Good painting is often a combination of what seems to be contradictory ideas. This project is an example of one of these apparent contradictions: you must be careful to get good shapes while, at the same time, you must remain spontaneous and free.

Because a beginner can't do both, your practice projects have alternated back and forth between the two ideas. Now, however, try to bring together all that you've done before. This will involve paint consistency, good values, good shapes, spontaneous brushwork, and good color.

Simplicity is the key. Make the shadow shapes simple and try to tie them all to-

gether into a connected whole. Avoid isolated islands and strings of shadows. Don't confuse light areas by adding values that are too dark for them. In the same vein, don't tamper with shadows by adding any value that's too light. Darks should be basically one value, not shadows within shadows.

For this project, you'll use these colors: cadmium red light, cadmium yellow lemon, yellow ochre, cerulean blue, Hooker's green, ultramarine blue, cadmium orange, raw sienna, burnt umber, and burnt sienna. The additional earth colors and cadmium orange aren't absolutely necessary, but I feel you should explore the various colors at hand and decide whether they appeal to you.

The other materials will be the same as usual with the addition of a 2B pencil and kneaded eraser.

Set up your palette so that you'll be able to start right in painting after you've sketched in the figure. Hopefully, the spontaneity in the pencil work will carry on into the brushwork—if you don't have to stop and squeeze out your color as you paint. So get this task over at the beginning: squeeze out the suggested colors.

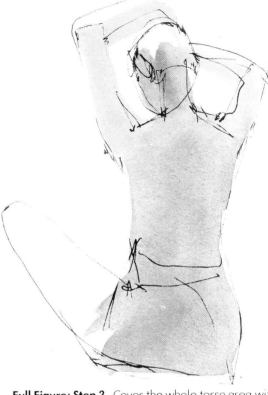

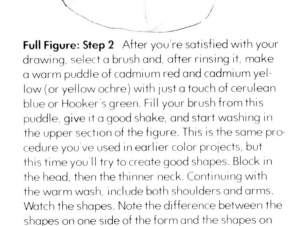

Full Figure: Step 1 Make a light sketch of your figure, not a careful rendering. Make your drawing about 10″ high. This is a good average size, not too big to cause proportion problems, but big enough to allow freedom in your brushwork. Your sketch should be only a guide for your wash. The lines you make should *not* be just filled in. If the drawing goes badly, erase and make some corrections, but don't overdo this. I generally start my drawing over rather than correct it, since erasures disturb the paper. Washes won't sit nicely over a heavily erased area.

Full Figure: Step 2 After you're satisfied with your drawing, select a brush and, after rinsing it, make a warm puddle of cadmium red and cadmium yellow (or yellow ochre) with just a touch of cerulean blue or Hooker's green. Fill your brush from this puddle, give it a good shake, and start washing in the upper section of the figure. This is the same procedure you've used in earlier color projects, but this time you'll try to create good shapes. Block in the head, then the thinner neck. Continuing with the warm wash, include both shoulders and arms. Watch the shapes. Note the difference between the shapes on one side of the form and the shapes on the other side of that same form.

Full Figure: Step 3 Cover the whole torso area with cool tones. Cerulean blue or Hooker's green will be the major color here mixed with a small amount of the warmer mixture. Work fairly quickly to get a good wet-in-wet blend between the warm and cool areas.

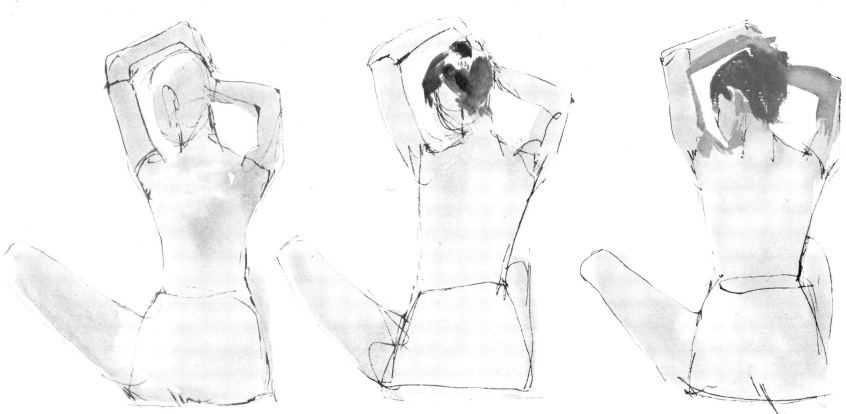

Full Figure: Step 4 Back to the warm colors. Start with the left knee and brush toward the cool torso. Finish the legs, getting a blend between the cool lower torso and warmer legs. Probably the wash will still be damp, so blot the hip and upper torso a bit to lighten these two areas. They will be the lightest lights in the final stage. Allow this to dry.

Full Figure: Step 5 Now add the shadow shapes, using the procedure in Project 17. For the dark hair, mix up a combination of burnt sienna and ultramarine blue. You might also try it with some alizarin crimson and Hooker's green. Experiment! Don't always use the same two colors. Darks are the place for rich color. Mix the darks on the palette, start blocking in the area, and then add some pure color wet-in-wet. Let some pure blue, green, or alizarin show. Don't feel that everything must be blended.

Full Figure: Step 6 While this is still wet, go back to rinse the brush and mix up the shadows. Use a combination of cadmium red light, raw sienna, and cerulean blue or Hooker's green. In this particular pose, the hands are the natural beginning place for shadows because there are soft edges between the dark hair and the adjacent shadows of the left hand and right upper arm. Starting at the wrist, carefully articulate the thumb, a graceful little touch. Allow the warm, dark color to blend with the hair. Now back to the water jar, and give your brush a rinse in case you picked up any of the hair color. Finish both arms. The left arm has very definite shadow shapes which describe the arm's muscle structure while the right arm has a simple shadow silhouette.

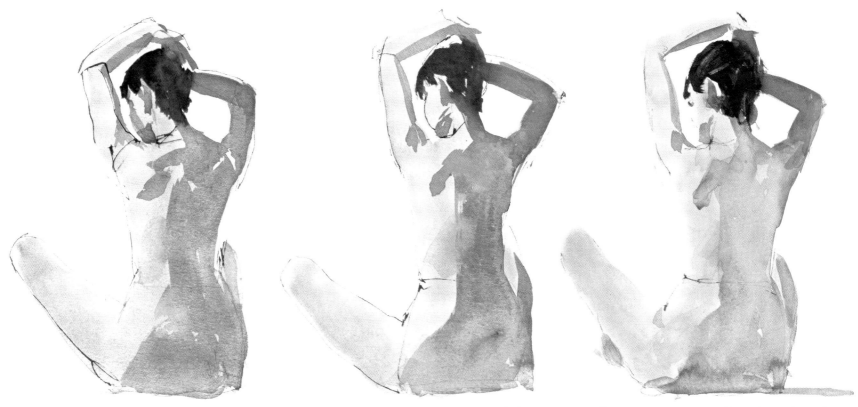

Full Figure: Step 7 Be concerned about shapes. The structure of the back is at once very broad and simple, but also quite exact in explaining the structure and conformation of the back. The straight form of the shadow on the back—as opposed to the curving shadow on the lower torso—is interesting. Continue with the cooler shadow areas here. The cerulean blue or Hooker's green should dominate. Don't put any small darks out in the light except the dark that indicates the underplane of the shoulder blade. This is a small dark, but a very important one. Soften the lower ribcage with cleansing tissue or your brush after it has been rinsed and shaken, and allow some of the shadow to flow out into the light. Add warm shadows in the right leg. Leave the left leg untouched.

Full Figure: Step 8 Allow all this to dry before adding the few middle tones. The major decisions are made; these few middle values are not only for the sake of finish, but also for the sake of explaining areas that need help. Shadows should be a simple, single value if possible, but sometimes you need to add further darks. In the case of the right arm, it doesn't recede enough if it has the same value as the rest of the shadows. Add a darker overwash here. Softening the shadow edge is usually sufficient for making middle transition values.

Full Figure: Step 9 Let's add another value to finish the figure and to make some of the transitions from light to dark more subtle or more definite. Use a wash somewhere between the shadows and the lights for this additional tone. Add this middle wash over the shoulder blade from the shadow up to the neckline, describing the shoulder blade. Add a middle tone in the lower torso to stress the roundness of this form.

19

FIGURE IN BACKGROUND

The work you've previously done is really in the realm of figure studies. Now you'll incorporate these studies into an environment and paint a picture of a figure.

To do a successful painting, the whole picture must be considered. You should be thinking of the background while you're painting the figure and thinking of the figure while you're painting the background.

Keep the surroundings simple, without obvious color and value changes. (If you squint your eyes and look at your picture, you should see a single, fairly dark mass surrounding a fairly light figure.) An overworked background is always a danger.

As a starter, I'd use a plain background of a solid color, which allows the figure to take up as much of the picture area as possible. Don't paint a half sheet (15" x 22") watercolor with a 6" figure and fill in the rest of the paper with background color. If your standing figure is only 6" tall, the entire picture area should probably be no more than 8" x 4". Of course, this relationship of subject to picture area is meant as an example, not a rule.

The colors in the background will always be lighter than when they were wet. That's good! Extremely dark values, directly adjacent to the figure, destroy the feeling of space and atmosphere around the figure. The darkest dark should be in the figure, not in the surroundings.

Here you'll be using a simple, fairly dark background. It's the most typical background for a lighter figure.
The folds here are the easiest to paint since they can be indicated by simple, elongated stripes. There's no real problem of form. The main thing is to put in only the necessary folds. The strokes should be simple and direct. However, since cloth is soft, some soft edges are important for explaining the texture. The robe and its cast shadow should follow the curve of the figure.

The materials will be a number 8 brush, water, palette, pushpins, 2B pencil, drawing board, and tissue. On your palette, squeeze out alizarin crimson, cadmium red light, cadmium yellow lemon, cadmium orange, yellow ochre, raw sienna, cerulean blue, ultramarine blue, Hooker's green, burnt sienna, raw umber, burnt umber, and Payne's gray. This is a pretty complete palette, and you won't be adding any new colors. You'll also need a larger brush for the backgrounds. Try a flat watercolor brush; 3/4" or 1" would be best. (I don't use flat brushes very much since I have a large, number 15 round sable. A flat brush will do just as well and is much more reasonable to buy.) Select a half sheet of good quality watercolor paper. The figure may not fill the sheet, but later you can crop the paper so it won't be too large for the figure.

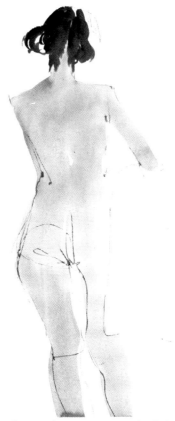

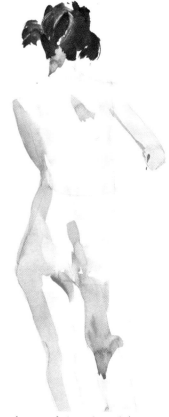

Figure in Background: Step 1 Sketch in the figure, using your 2B pencil. Never rush through the drawing stages, but be concerned with good shapes. Even though your sketch is very lightly drawn and certainly won't be followed exactly, always be as descriptive of the actual forms as possible.

Figure in Background: Step 2 Mix up the light washes on your palette and block in the figure. There should be obvious differences between the warm and cool colors. For the hair, work directly with pure color, instead of mixing the color on the palette. This is especially good in working with dark hair. Add the hair color wet-in-wet, perhaps dampening the paper first; burnt sienna and ultramarine blue are the main colors, but a touch of alizarin crimson and Hooker's green might be used too. The color will dry lighter, so use plenty of pigment with just enough water to make the color move and not "cake-up."

Figure in Background: Step 3 As it happens, the shadows take up very little of the figure area, but still mass them in carefully, making sure they express the form of the body. Work quickly, softening some of the edges in the middle back (where the upper and lower torso meet) and in the buttocks and allowing some shadow color to work out into the lights.

Figure in Background: Step 4 Quickly add some cool middle values to the base of the spine and the lower back. Always keep a tissue handy in case this gets too dark or too important. Keep these middle values definitely lighter and less important than the shadows. There could be many other middle values, but omit them to keep the figure simple —uncluttered and broad. You can't really judge how to finish the figure until you've added the background. When the background is finished, the figure may require more work, but wait and see.

Figure in Background: Step 5 While the shadow is still damp, start scrubbing in the background, working the brush into the paper with a variety of strokes. Use burnt sienna, Hooker's green, some burnt umber, alizarin crimson, or any dark color. Yellow ochre or cadmium orange would be too light and the values would not be dark enough. Carefully describe the outside shape of the left shoulder which is in the light, but work quickly to make a soft edge where the left side of torso and arm are in shadow. The edge between this shadow area and the background should be nice and soft. At the same time, work the background color carefully around the light boundaries.

Figure in Background: Step 6 When the background has dried, use two almost parallel strokes to indicate the cloth that the model holds and soften them with a tissue. Use a short stroke to show that the cloth is draped over the arm. The bulk of the drapery can be suggested by a simple, circular stroke at the bottom. If the dry background needs some more color variety, brush a clear wash over it, and after the wash sits a moment, drop pure dark colors into the damp areas. For texture on the wall, I use "spatter" work. Fill the brush, and knock the handle against a finger to stop the brush abruptly and make the paint fly. To mask off the figure, hold a piece of paper over it.

20

BRUNETTE SEATED FIGURE

The following projects are reconstructions of completed paintings in which the techniques you've just read about are applied. This figure and almost all of the other examples were done in a life class. One of the problems of a life class is coming to a consensus on a pose; it's wild when five or six people all have different ideas on what the pose should be. You may be lucky enough to have one person in the group who's clever about posing a model. If you're good at finding a pose, it's probably because you allow the model to sit, stand, or lie in a perfectly natural way. As a rule, "posed" models are hackneyed and dull. One solution to this is

to keep your eye on the model while people are setting up their stuff. She might sit or stand in just the right natural position that would make a good painting.

The other problem in a life class is finding five or six equally good points of view —one for each person. Every pose has just two or three equally good angles, and the key here is to be fast on your feet to get one of the good spots in the room. A pose like this particular one looks rather "bunched up" from the side! So I chose the direct back view. I was especially impressed by the shapes evident in the shoulders. Angular forms like these work well with the more curving forms.

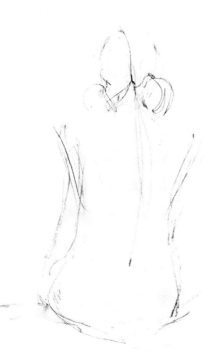
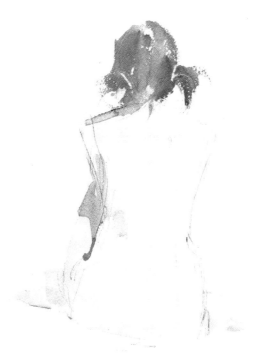

Brunette Seated Figure: Step 1 I sketch the figure in with a 2B pencil on rough Arches paper. The sketch is quite lightly done, and I keep my pencil work free and spontaneous. I stress the broad shoulders, which make very attractive shapes in relation to the rest of the figure. I make the right side straighter than the left side. (Make sure you study and understand the shapes.) I lightly sketch in some drapery.

Brunette Seated Figure: Step 2 I paint in a light first wash. Since the model has fair skin, there are no dramatic color changes, and I use the same colors I've mentioned: cadmium red light, cadmium yellow lemon, yellow ochre, and cerulean blue. For the cool gray in the drapery, I mix a touch of cadmium orange with the cerulean blue. I start the torso with warmer color in the arms and shoulders, and the color becomes cooler as I add more and more cerulean blue.

Brunette Seated Figure: Step 3 For the hair, I use burnt sienna and ultramarine blue. An area like the hair should be as rich in color as possible, since it will always be less exciting when dry. I use the wet-in-wet technique, adding pure color directly from the palette. Next, I mix a shadow wash, using cadmium red light, raw sienna, and a touch of cerulean blue and Hooker's green. The cast shadow runs along the left shoulder. I block in the large shadow which describes the border of the torso and a section of the leg. It's important to generalize shadows in this way. I never paint two separate shadows for two adjoining areas, but I always mass in as much shadow area as possible with a single wash. I soften the shadow as it reaches the waist area, and I allow some of the shadow color to work out, forming a middle value. The construction of the back is complicated so I avoid most of the back's small forms.

Brunette Seated Figure: Step 4 The hair has dried too light and dull. I pass a clear wash over the hair, blot it a bit with a tissue, and let it sit a moment. Then I restate the darks, using blue and burnt sienna. To see if I can make the color a bit richer, I add a touch of burnt umber and Hooker's green. I blot the hair in one or two places to lighten those areas that need lightening. Then I scratch out some indications of hair strands with my fingernail. The darker, richer hair sets off the figure much better now. I don't want to confuse the lights with small darks that will "break up" the big, simple form of the figure. So I mix up a light puddle and indicate a few more of the important middle values. The shoulders are held forward, creating an important side plane in the form of a curve, reaching roughly from the left hip bone to the inside edge of the left shoulder blade. This is most obvious in the mid-section of the upper torso, so that's the part I indicate. The bottom of the lower torso is curved under, so I indicate a darker wash there too.

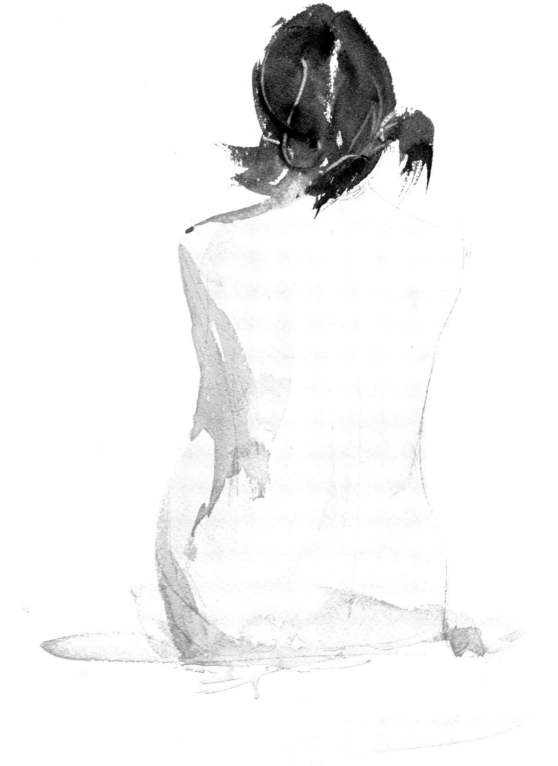

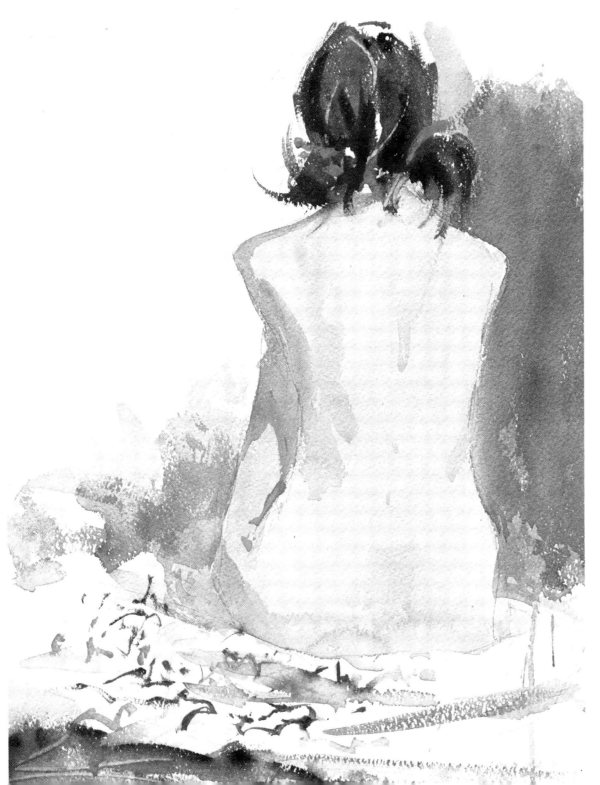

Brunette Seated Figure: Step 5 15" x 11", Arches paper. I keep the background high-keyed to enhance the airy, light feeling I'm after. I want a cool, neutral color back here. I use some ultramarine blue, alizarin crimson, very little cadmium yellow lemon, and in the lower sections, Hooker's green and cadmium red light. I keep a tissue handy for blotting and lightening. The edges are given special attention—harder edges face the light, while soft, lost edges are found away from the light and in shadow. I don't finish off the entire background, but the completed part forms a diagonal curve through the picture. The figure itself is very simple and seems to need something, so I add an indication of pattern in the drapery. I also add some pure pigment to indicate hair ribbons. This gives a nice color accent in the upper section of the figure.

21
BLOND RECLINING FIGURE

Some models understandably don't want to stand or sit for three hours, a normal length for a life class. Even with a five minute rest every twenty-five minutes, a standing pose is rough. Most models respond happily to the suggestion of a horizontal pose, and often they promptly fall to sleep. This works very nicely for the artist, since he automatically gets the nice, natural pose he's after. On the other hand, prone poses are generally harder to draw. The normal proportions are often out of whack, and it takes practice to draw "across" rather than up and down.

The other problem with this particular demonstration was the lighting. The painting was done in natural and rather diffused light. This meant that there were no clear-cut light and shadow shapes. I find this the most difficult type of figure painting, and it really reminds me of how handy those good old shadow shapes are!

Preliminary Sketch

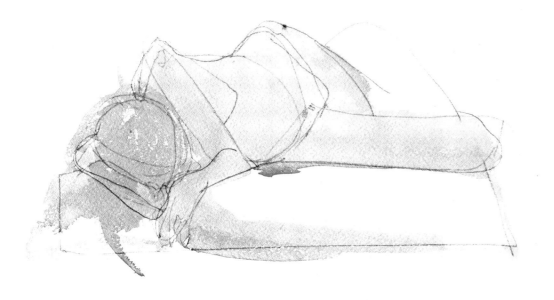

Blond Reclining Figure: Step 1 The model is a blond, but the skin color isn't drastically different from the skin tones in the previous demonstration, although there does seem to be a bit more warmth. The colors are my old favorites: cadmium red light, yellow ochre, cadmium yellow lemon, and cerulean blue, and I mix all of the colors on the palette. I use the warmer tones in the shoulders, arms, head, and legs. I mix a little cerulean blue on the palette with the other colors for the torso, where the cerulean blue dominates. I wash in the hair with a little cadmium yellow lemon and yellow ochre. I want this to be light, but I let the cadmium yellow dominate to give warm, light areas in the hair. However, yellow hair isn't truly yellow, but quite neutral, so I keep the cadmium yellow in check with the ochre. I leave some white paper to stand for the lightest lights. Finally, I wash in some cerulean blue with the warm tones for the shadows and cast shadows. I allow this first wash to dry.

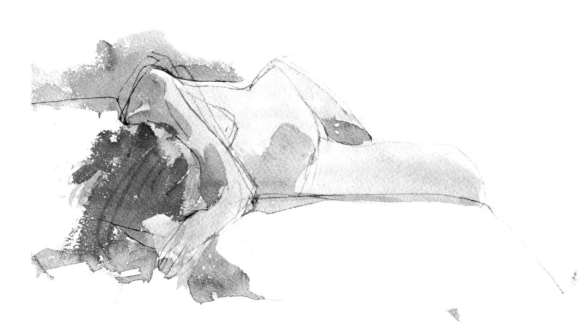

Blond Reclining Figure: Step 2 Here I add the first shadow shapes and the major planes. The head will be difficult. Only the nose and forehead really show, and these forms must be right to make this area come off. With a single wash, I very carefully block in the shadow on the arm and the dark area between the face and left upper arm. The shadow only goes part way up the upper arm. I could run one shadow from the shoulder right down to the inside of the elbow, but this wouldn't show the conformation and muscle structure of the upper arm. Now I add the rest of the shadows around the head. I combine the hair and cast shadow over the upper arm. Working wet-in-wet, I wash in the shadow side of the left shoulder with a cooler color. With the same wash from my palette, I block in the very important plane of the stomach. This is a general shadow because I wanted to get the feeling of bulk in this lower torso area. I wash in some background and the shadow for the left leg.

Blond Reclining Figure: Step 3 Since the whole lower torso forms a plane turned from the light, I indicate slightly cooler, darker washes here. I also show the left breast in a plane away from the light. I add shadow to the right leg. I apply each wash with deliberation. The result should look spontaneous, but there's nothing spontaneous about my thinking. I add shadow features to the head and brush in more of the background.

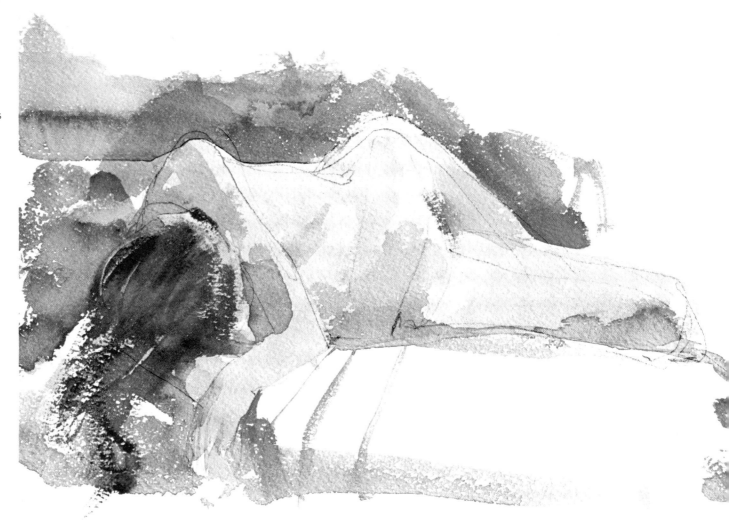

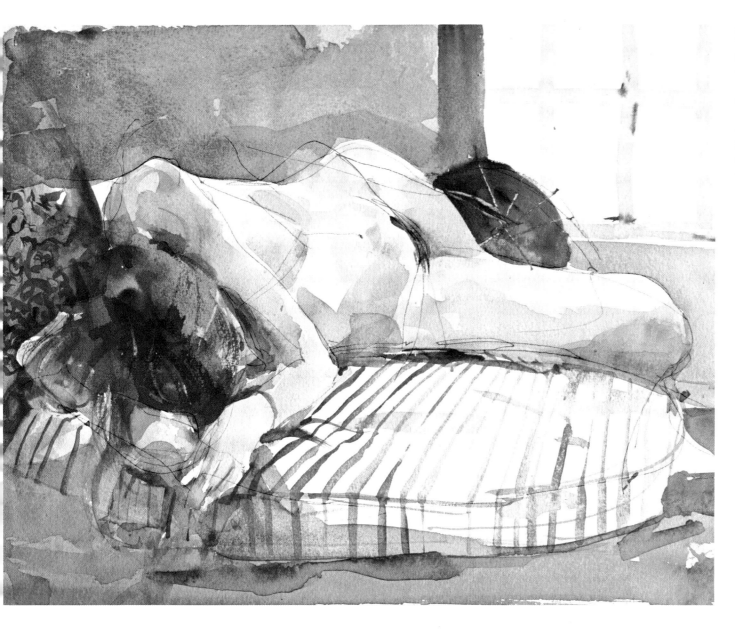

Blond Reclining Figure: Step 4 11" x 16½ ", Fabriano paper. I finish the background before going on with the figure. When the background is complete, I add a few more minor washes and value changes to the figure. Notice that I,ve left many hard edges within the figure. I like this quality, although I could have softened and polished the figure with successive, subtle graded washes for a different effect.

22

BLACK SEATED FIGURE

One of the most attractive things about a dark complexion is the color possibilities. You should concentrate on color whenever you're working with shadows or with any darker value. One reason for this is that you can get away with using strong, pure color in darks; if you tried the same thing in light areas, the color would be discordant and harsh.

As a general rule, a darker complexion will have the warmest color in lower-keyed areas. The lights will generally appear cooler. I've stressed the use of fairly weak colors in flesh tones up until now, but you should break away from this when you paint a darker complexion. Here I often use phthalo blue in preference to ultramarine. (Cerulean is really too light to work well in very dark areas.) Also try alizarin crimson, a dangerous color in lighter complexions.

In applying the color here, I use a different sequence. I've been working from light to dark. This time, I'll work from dark to light. I'll complete (or almost complete) single areas before moving on. I often use this procedure when the figure has no definite light and shade or when I have a very low-keyed figure where darks predominate.

Preliminary Sketch

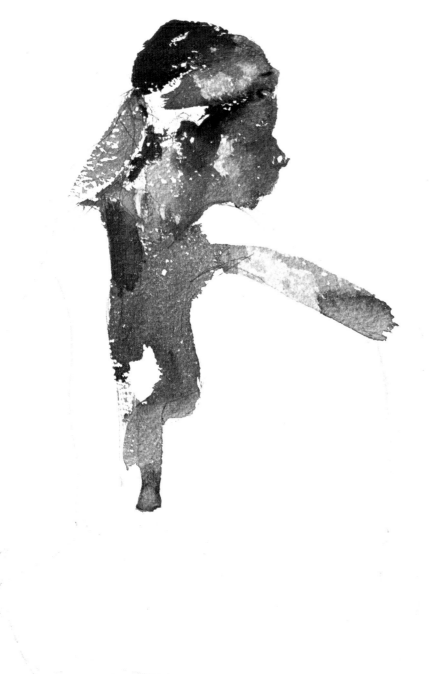

Black Seated Figure: Step 1. I start off with the forehead, using a rich, cool wash of ultramarine, raw umber, and a touch of red. I try to make this first wash dark enough with the first try. I work around certain facial areas to leave white paper for a light-struck effect. I soften some of the edges of these light-struck areas with my brush and a tissue. I work with warmer colors as I get into the cheeks and nose. Painting wet-in-wet, I start using cooler colors in the chin and around the mouth. I make obvious color changes in the head, and I go on to the neck and torso. I blot the left arm to lighten it.

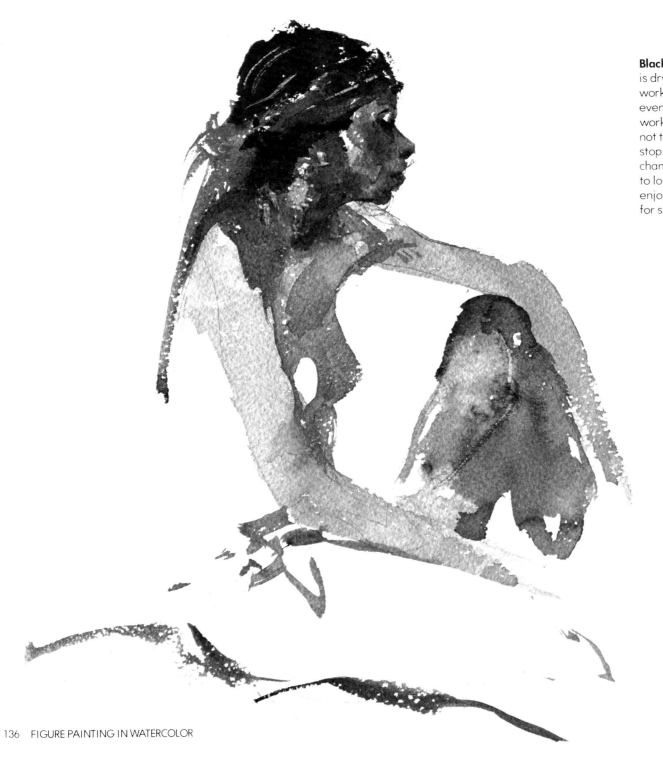

Black Seated Figure: Step 2. The front of the torso is dry now. I go on with both arms, but I'm also working on the head to bring it toward a finish even before the rest of the figure is completed. I work in wet-in-wet and add overwashes. I try hard not to disturb the previous washes, but this doesn't stop me from working into areas that I want to change. Using this approach means that I'm going to lose quite a bit of the freshness that I usually enjoy, but I don't worry about it here. I'm aiming for subtlety and complexity.

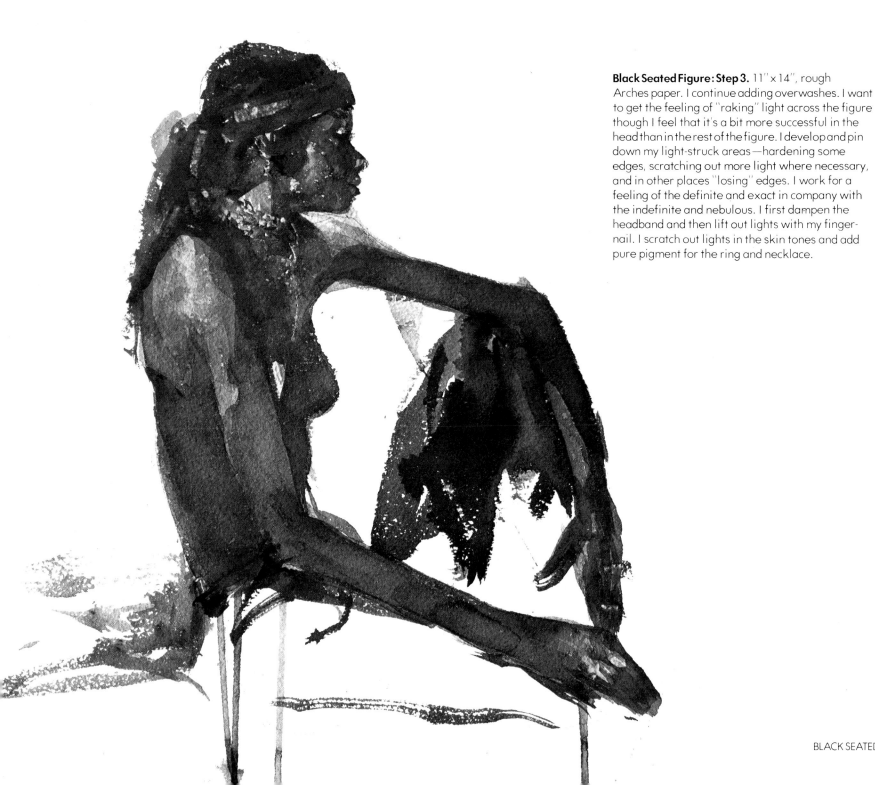

Black Seated Figure: Step 3. 11" x 14", rough
Arches paper. I continue adding overwashes. I want
to get the feeling of "raking" light across the figure
though I feel that it's a bit more successful in the
head than in the rest of the figure. I develop and pin
down my light-struck areas —hardening some
edges, scratching out more light where necessary,
and in other places "losing" edges. I work for a
feeling of the definite and exact in company with
the indefinite and nebulous. I first dampen the
headband and then lift out lights with my finger-
nail. I scratch out lights in the skin tones and add
pure pigment for the ring and necklace.

23

FIGURE IN SUNLIGHT

Painting a figure in sunlight presents obvious problems, but if you can find a model who isn't shy or if you live in a secluded area, painting a nude in sunlight is a painting experience not to be missed! I'm particularly interested in light and what happens when it strikes the side of an object or a figure. I think it's safe to say that sunlight brings out color possibilities that are impossible under artificial light.

As you'll see in the course of the following steps, the values from shadow to light are considerably higher in key than under artificial light. This is especially noticeable in the shadows, which are very much influenced by reflected light. I'd really prefer that you concentrate on reflected light in your shadows rather than concentrate on reflected color. Certainly there's reflected color too, but it's always much more subtle than the value caused by the reflected light. As an experiment, hold your hand next to a very bright color. You'll see a suggestion of reflected color, but notice how soon this reflected color disappears as you move your hand away from the colorful object. Even though I want you to be aware of lighter shadows in sunlight, remember that shadows are still shadows and that they can't ever be as light as the main lights.

Preliminary Sketch

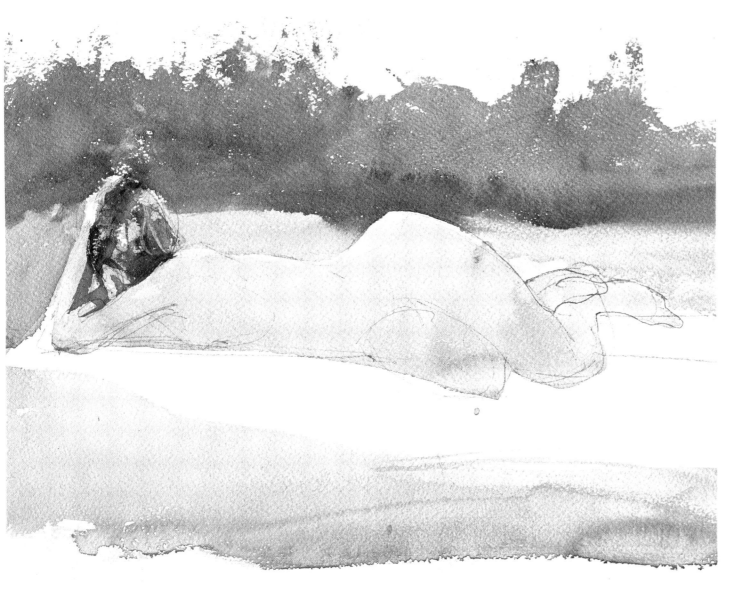

Figure in Sunlight: Step 1. I wash in the whole figure with my first wash, using my basic colors: cadmium red light, cadmium yellow lemon, and cerulean blue. I want this figure to be "swimming" in sunlight, so I keep the first wash quite light, but as rich as possible. Around the figure, I use mostly cadmium yellow lemon, with just a hint of cerulean blue for the grass. The distant trees are a combination of cerulean blue, cadmium yellow lemon, and raw sienna. I leave the white cloth untouched. White paper will stand for this area. As the lights are drying, I start thinking about the shadows. I'll stress color changes rather than value changes, so I want both the lights and the shadows to be extremely simple. As soon as the light areas are dry, I wash in the warm darks and carefully articulate the shadow shapes in the complicated area around the head and forearms. Next, I indicate the shadow areas of the hair with burnt sienna. I scratch out a few hair strands with my fingernail.

Figure in Sunlight: Step 2. Now I'll do the shadows describing the upper arm and torso. I paint the cast shadows on the cloth at the same time as the body shadows. Warm reds and yellows in the elbow area give way to much cooler color (cerulean blue) around the shoulder and torso areas. I use mostly cerulean blue with a touch of yellow or orange added for the cast shadows. I allow the shadows of the flesh tones and the cast shadows on the cloth to blend together. I make the large shadow on the upper and lower torso high-keyed, but since the very light cloth reflects into his large shadow area, it stays quite cool. I give careful attention to the shape of this shadow. Also I add some darker values to the background.

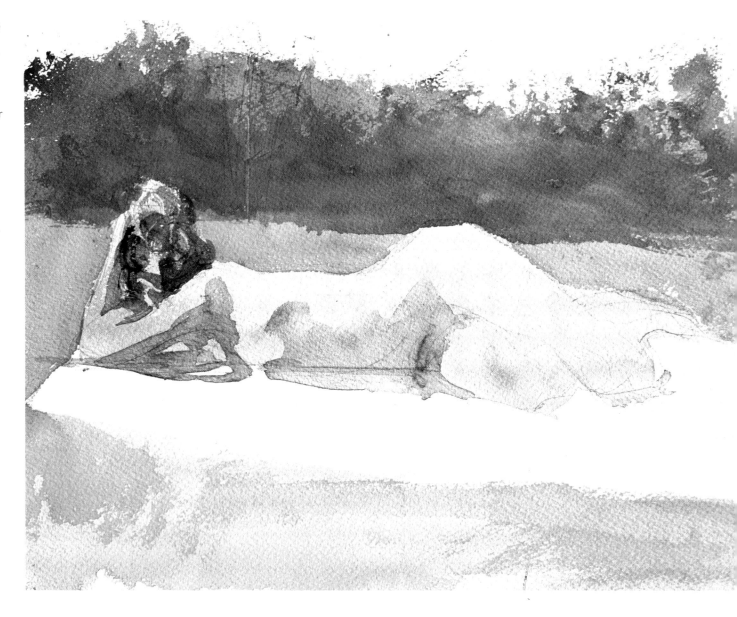

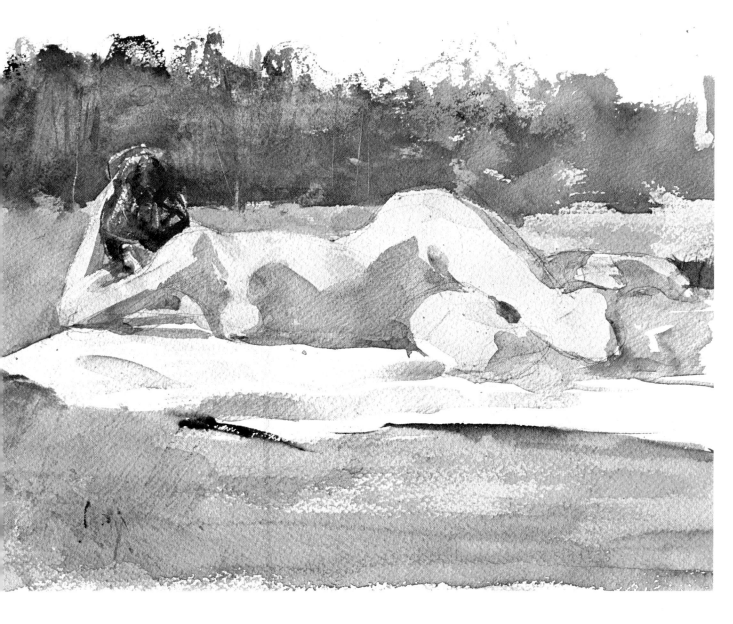

Figure in Sunlight: Step 3. 11″ × 15″, rough Arches paper. I complete the shadows in the legs and feet and I add the cast shadows around the legs. I make soft edges between these shadows and the cast shadows. Now I go back and add a few middle values. The plane of the ribcage and shoulder is made very subtle, since I don't want to disturb the simple light-shadow relationship that gives the figure a feeling of light. The few important folds in the cloth are indicated. Again, a minimum of strokes! I add the finishing touches in the landscape, and it's done.

24
CLOTHED MALE FIGURE

I'm particularly fond of old photographs and enjoy working from them, although I've mixed feelings toward photographs in general. I don't feel that an artist should cut a fine photograph out of a photography magazine and copy it. Usually the picture is so good on its own that the copy is bound to come off second best. I suppose you could say the same for my love of using old photographs.

Perhaps the crucial point is what you do with your photographs. If you're able to take your painting beyond a literal copy of a photograph, I think it's perfectly fine to use photos. Maurice Utrillo did some of his best paintings of Montmartre from postcards. It would be my guess that an artist of the caliber of Utrillo could make a good painting from a postcard of Disneyland. It's not really the reference, but how you use it that counts.

This particular painting was done from a photo of one of my favorite painters, Toulouse-Lautrec. He must have been an amusing man who didn't take himself very seriously. I've tried to get this quality into my painting.

What obviously stands out in this figure is the arrangement of light and dark masses of clothing and skin tones, set side by side. Each area has an overall value of its own, despite the effect of light and shade.

The effects of light and shadow should never change the general value pattern of the subject. Instead, the pattern of lights and darks should *dominate* the light and shade on folds and other small forms.

Here the white shirt is obviously lighter than the adjoining vest, which is consistently darker throughout. If there were a strong light shining on the figure, it's possible that these local color values might get confused: the shadows on the white shirt might seem darker than a light-struck section of the vest. But in a painting, a white shirt should always look white, even in shadow, and a dark vest should always look dark, even in strong light.

Preliminary Sketch

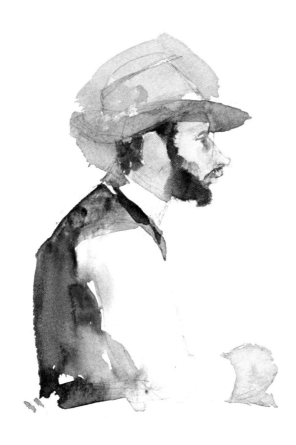

Clothed Male Figure: Step 1 First, I wash in the face with both warm and cool colors—more red in the cheeks, nose, and ears. The whole face, neck, and hands are more or less the same value. Next comes the beard. I don't make it too dark yet. I want the edges of the beard to make a gentle transition into the face values. Notice that I soften some of the beard edges with my brush. In some spots, the flesh tones aren't quite dry so the beard happily blends in at these spots. Next, I do the hair, using the same procedure as in the beard. The hat will have the most value changes, since the underside of the brim is turned completely away from the light, but it's still a good deal lighter than the beard. I leave the white shirt untouched save for the very back, where I allow some of the color to move into the collar to stand for the shadow. The vest is going to be consistently one value, with several colors used wet-in-wet. I use fairly pure color here, adding almost pure pigment into the damp area of the vest. I start with raw sienna and Hooker's green at the top; then I add some ultramarine blue to the lower sections of the vest. To lighten the shoulder, I blot a bit with a tissue while the shoulder area is still wet. I allow some of the vest color to flow into the sleeve area to soften the shadow edges of the sleeve. I blot with a tissue to make sure this doesn't get out of control.

Clothed Male Figure: Step 2 I use a warm gray to wash in the canvas which is standing behind the artist. For this I use some cerulean blue, raw sienna, and a touch of red. As always, I'm concerned with shapes, and I make sure that the white area I've left has the feeling of a loose fitting sleeve. I make the trousers a cooler gray, quite noticeably lighter than the vest; I use ultramarine blue, alizarin crimson, and a little cadmium yellow lemon. Finally, I add the shoes and a stroke to start the stool. Since the trousers are still wet, I have a soft edge between the shoes and trousers.

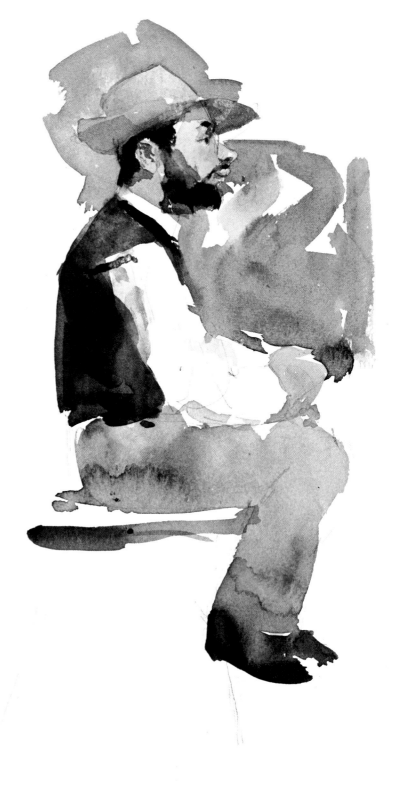

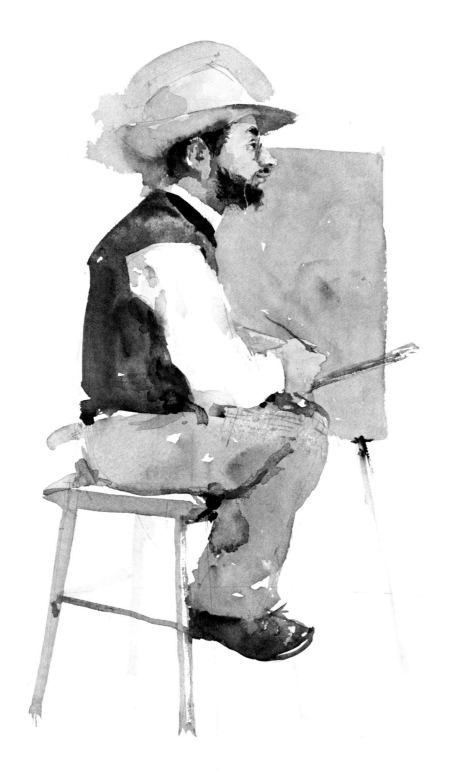

Clothed Male Figure: Step 3 15" x 10", Fabriano paper. Now all that I need is to pull things together. I articulate the face more, going back into the beard in a few places with my darkest dark. I re-dampen the beard area with clear water; blot it a bit with a tissue; then add the darks wet-in-wet or with drybrush for the darkest darks. I use ultramarine blue and burnt umber here, but I don't paint darks up to the border of the face. I keep the darkest darks in the middle section of the beard and hair. I also add a few dark accents around the hands and legs. I don't use any folds except for a single indication at the knees. The figure has a convincing quality without any real indication of folds. Hard and soft edges are very important form makers in this picture, so I use very soft edges on the back of hat and hair and around the shirt. I use only a few simple strokes to finish the easel and show the stool.

25

CLOTHED FEMALE FIGURE

Painting drapery is difficult and really takes some study to master. To do a proper job I'd have to devote a major part of this book to what are called "laws of folds." If you have a good eye and excellent pencil and brush control, you can manage a pretty convincing piece of drapery by careful observation, but it's much more desirable to understand what you're doing. Several drawing books cover drapery in detail. They're worth reading.

If you're new to watercolor painting, you should sketch in the fold areas very lightly. These fold indications should not simply be copied from the model. Instead, they should be the result of an understanding of the basic framework of folds.

In this particular subject, there are several different kinds of folds, but they all have one thing in common: they explain the form of the body underneath the clothing. If folds don't show the structure of the body, they're quite worthless and better left out. Finally, put in only the most dominant and important folds, and leave out any that aren't necessary!

I use opaque white in the final stage of this project. Opaque white can make just the right finishing touch, but it should never be used as a crutch for a poor painting. Here it picks up some light-struck areas in the dress and scarf. The largest areas of opaque color are in the skirt, especially on the right side.

Preliminary Sketch

Clothed Female Figure: Step 1 The face is mostly in shadow. I start off with fairly dark values because the subject has a dark complexion, but I leave the light-struck nose untouched. I mass in the shadow areas of the hat with raw sienna and a touch of blue. As I move into the bandanna, I make the shadows cooler. I always use complementary colors for my grays, and here, I use blue with a touch of orange, and some purple with a touch of yellow. Some of the bandanna's shadows are pure blue. I use a spontaneous approach, although I carefully plan where the wash will go. I wait a few seconds to let the blouse areas dry before blocking in the neck. Some blending is good, however, so I don't wait too long. I next wash in the flesh tones of the neck and the right side of the blouse, which are in shadow. I add the background. Hard edges are desirable on the left side, which is in sunlight, but I want softness on the shadow side, so I add the background while the shadows on the blouse are still wet. I add the hands and adjoining cast shadow under the left hand. I make a soft edge between the left hand and the adjoining shadow.

Clothed Female Figure: Step 2 I go back and relate the face to the underside of the hat. To give the face a raking light, I lift the major light in the right cheek and forehead with a dampened tissue and wait for this area to dry before working into it again. I restate the neck, then as I start to develop the underplane of the breast, I see that I've made a mistake and put a dark where the light-struck area should be. I dampen a tissue with clear water and lift out this dark. After it dries, I restate the shadow on the underside of the arm. I don't make a solid plane, but to suggest the folds, I make several smaller, dark indications. I darken the under-plane of the hands and further develop the cast shadows on the skirt. Now, I go on to the very difficult folds in the upper right arm and shoulder. I make sure that my value consistency and color are correct in the mixture on the palette. Then I give each single stroke considerable thought so that it will explain the cloth as well as the overall form of the area. I brush in more of the background.

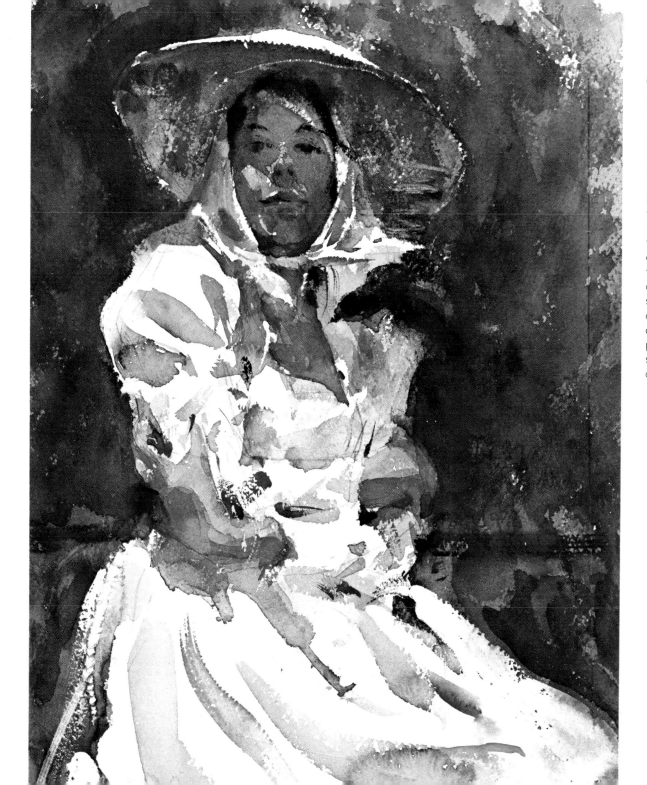

Clothed Female Figure: Step 3 13" x 9½", rough Arches paper. I stroke in the folds on the skirt. It's a very full skirt with an involved pattern of folds. Again, I try to put in only the most important folds, and these I do with care. Even though these strokes look like they're dashed in, this really isn't the case. Each stroke is planned and given careful thought. I go back to develop the feeling of light in the face. Some of the small lights are scraped in carefully with my razor blade, but I don't dig up the paper. I try to just lift off the color. Razor blade work is fine, but I don't overdo it. I sponge off larger light areas with a tissue and then restate them. I add touches of opaque white to pick up light-struck areas in the dress and scarf and to make the right side of the skirt seem fuller. For other light-struck areas, I use a razor blade. Using drybrush, I indicate some bracelets with some cadmium yellow pigment. Finally, I finish the background, softening some edges and hardening others in the boundaries of the figure.

26

FIGURE GROUP

Painting a single figure in watercolor is enough of a challenge to satisfy most of us, but sometimes it's necessary to paint two or more figures within the same picture. My greatest fear is that I'll get through the first figure successfully but botch the job in the second or third.

One thing you'll learn with experience is to do doctoring jobs on apparently ruined paintings. If you find one of the figures in your composition below par, try not to worry about it. Just continue on to the finish. Two things will happen. First, and most desirable, the figure won't really seem so bad after all. No painting is ever 100%, and parts that aren't quite up to snuff often make the good parts all the better by comparison. The second

alternative is that you'll be able to use your dampened tissue, your razor blade, or opaque color to correct the difficulty. Sargent's watercolors are often touched up with opaque color, and if *he* needed to correct, all is not lost!

Painting several figures is not only a problem of technique. I'm sure that composition is a much more important consideration. Unfortunately, if you're working on the spot with a minimum of time, it's not always possible to make the compositional changes you'd make in a landscape that's stationary. Because of this, I don't worry very much about composition in figure sketches. I'm mainly interested in getting gestures, color, and the spontaneous quality that I think happens only in on-the-spot painting.

This painting is of a calm day on Long Island Sound. The boat was a wonderful old Chesapeake bug-eye ketch owned by two of my favorite people. Betty, on the right, is one of the owners, and she's repairing sails with the help of a boy who was working on the boat. The sails seemed to make a nice background for the two figures, but in retrospect, the composition might have been better with just the mast and the strong dark of the open hatch. No matter, the sails were there, and the people under them, and I wanted to catch the gestures of the people before they moved away!

Preliminary Sketch

Figure Group: Step 1 Starting with the figure on the left, I paint in the warm shadow areas of the face. Working quickly and not worrying too much about colors running together, I add the hair, using a touch of phthalo blue and burnt sienna. Some of the hair color runs into the face, and I blot the face area with a tissue. Next I paint the red towel that the boy has around his neck. I use pure cadmium red. For the shirt, I want to take advantage of my white paper so I dash in only the important dark folds. I also brush in some blue for the sky, again to help make the white stand out. I want to establish the darkest darks early, so I add the dark accents in the trousers and hatch. Here I use phthalo blue and burnt umber. The values in the sail bother me, so I use a middle value gray. I'll probably have to go darker here, but for now I just want to cover the paper.

Figure Group: Step 2 I wash in the sails, trying to get some good color variety into them. It's impor-tant to be courageous in this stage. With drybrush I work in the boom running along the bottom of the sail. I want some blend, but I also want to avoid too much of the dark color from the boom running up into the sail. I start working on the other figure, leaving the white shirt untouched. I wash in all the skin tones with the same color and value, keeping the colors rather warm. While the skin tones are still wet, I blot the knee to lighten it. The very dark values in the hatch are painted in with phthalo blue and alizarin crimson. Finally, I wash in the side of the cabin under the left-hand figure with a light, cool gray.

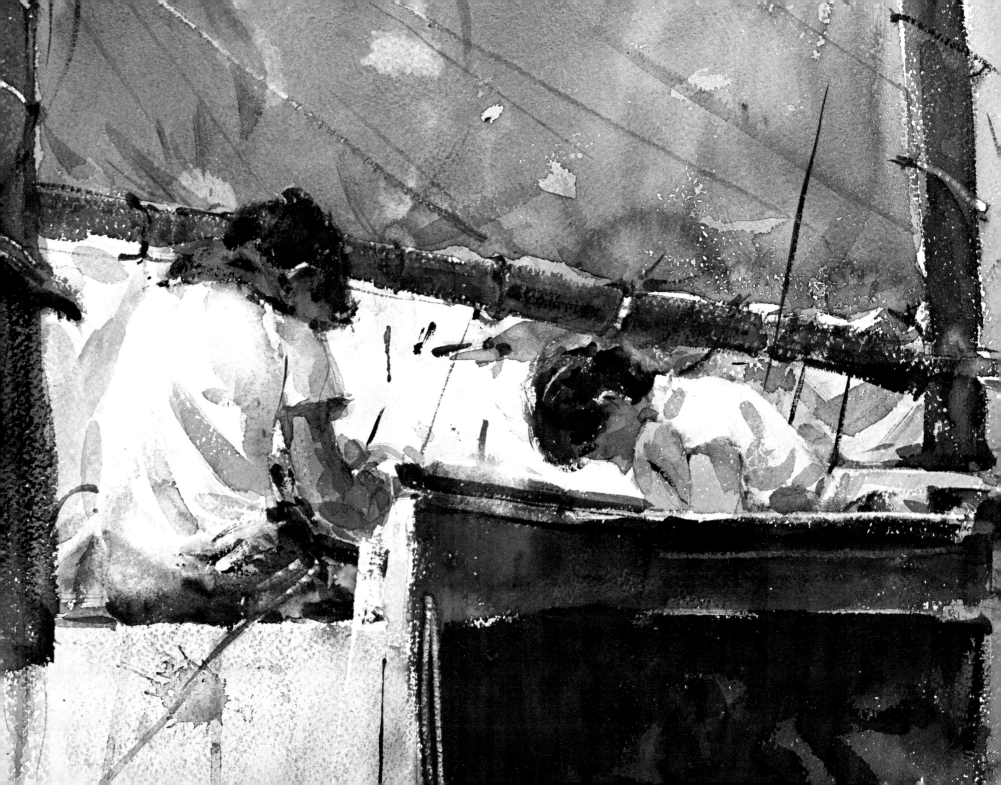

Figure Group: Step 3 12" x 17", rough Arches paper. I finish off the dark hatch and decide to go for darker values in the sails. I spend long moments looking at an area like this when I'm not sure of it. I hold my hand as if holding an imaginary telescope and stare through the hole. Sometimes I practically stand on my head, hoping that a new point of view and perspective will give me the answer. One advantage of working on the spot is that you don't agonize over the areas like this quite so much. The folds on the girl's shirt seem spontaneous, but they've been carefully thought out. There are only two values here—the overall value of the shirt and a single darker value for the shadows. I add some dashes of orange pigment for the highlights of the scarf. I suppress the desire to add more opaque areas; as a rule, I don't have much luck with this type of doctoring, but really prefer lifting out lights with a tissue or razor blade. The trousers of the figure have become too heavy and dark and the last thing I do is to sponge out the lower section of the torso, extending the shirt.

BIBLIOGRAPHY

Blake, Wendon, *Acrylic Watercolor*. New York, Watson-Guptill, 1970.

Barcsay, Jenö, *Drapery and the Human Form*. Budapest, Hungary, Corvina Publishers, 1958.

Brandt, Rex, *Watercolor Landscape*. New York, Reinhold, 1963.

Bridgman, George B., *The Seven Laws of Folds*. New York, Bridgman Publishers, 1942.

De Reyna, Rudy, *Painting in Opaque Watercolor*. New York, Watson-Guptill, 1969.

Guptill, Arthur L., *Watercolor Painting Step-by-Step*, edited by Susan Meyer. New York, Watson-Guptill, 1967.

Hogarth, Burne, *Dynamic Anatomy*. New York, Watson-Guptill, 1965.

Hogarth, Burne, *Dynamic Figure Drawing*. New York, Watson-Guptill, 1970.

Hogarth, Paul, *Drawing People*. New York, Watson-Guptill, 1970.

Hoopes, Donelson F., *Winslow Homer Watercolor*. New York, Watson-Guptill, 1969.

Kaupelis, Robert, *Learning to Draw*. New York, Watson-Guptill, 1966.

Kautzky, Ted, *Ways with Water Color*, 2nd ed. New York, Reinhold, 1963.

Kent, Norman, *100 Watercolor Techniques*, edited by Susan E. Meyer. New York, Watson-Guptill, 1968.

O'Hara, Eliot, *Watercolor with O'Hara*. New York, Putnam, 1965.

Pellew, John C., *Painting in Watercolor*. New York, Watson-Guptill, 1970.

Richer, Dr. Paul, *Artistic Anatomy*, translated and edited by Robert Beverly Hale. New York, Watson-Guptill, 1971.

Szabo, Zoltan, *Landscape Painting in Watercolor*. New York, Watson-Guptill, 1971.

Werner, Alfred, *Degas Pastels*. New York, Watson-Guptill, 1969.

Whitney, Edgar H., *Complete Guide to Watercolor Painting*. New York, Watson-Guptill, 1965.

INDEX

Edited by Adelia Rabine
Designed by James Craig and Robert Fillie
Set in 12 point Futura Book by York Typesetting Company
Printed and bound in Japan by Toppan Printing Company Ltd.